MANGA
Watercolor

STEP-BY-STEP MANGA ART TECHNIQUES FROM PENCIL TO PAINT

LISA SANTRAU

DAVID & CHARLES

www.davidandcharles.com

CONTENTS

EXERCISES

PROJECTS

FOREWORD

Painting with watercolors essentially means forgetting about formal painting techniques. Don't worry if you can't quite paint the apple in front of you, or if the rooster doesn't look like it does in the photo – watercolor isn't meant to accurately reflect reality. You're more likely to be trying to capture a feeling or create a certain atmosphere. It's about representing and abstracting the basics, yet manga is also often characterized by a love of detail. The two are by no means mutually exclusive, because the ability to create a soft atmosphere through color, for example, is exactly what constitutes a manga illustration. Using watercolors needn't be expensive, although you can invest in more costly materials. To begin with cheaper paints are fine, and they're usually already highly pigmented, meaning you don't need to use much and they last a long time. The beauty of painting by hand is that you can keep trying new materials. Just go to an art or craft shop to find different brands and materials. Some of us are addicted to drawing materials and trying out as many types of watercolor paper as possible, while others enjoy testing out paint pans, tubes and liquid paints.

Watercolor is supposed to be fun, so don't worry about everything being perfect or expensive. Set your priorities and try out whatever you like. If I can give you one tip, it's to invest in good-quality paper. Just a small paint box is enough to start with, as you can easily mix different shades yourself. A box of 12 colors is enough to get you going!

TEMPLATES

If you feel like quickly trying out the paint techniques as you learn them, you can find templates of some of the illustrations in this book via the link below. Make your own copies, try them out and get acquainted with watercolor. It's best to print out the templates and copy them onto watercolor paper using an LED light box or your window. If you have a laser printer, you can scan the templates and print them onto watercolor paper, just make sure it's not too thick for your machine.

www.davidandcharles.com/product/manga-watercolor

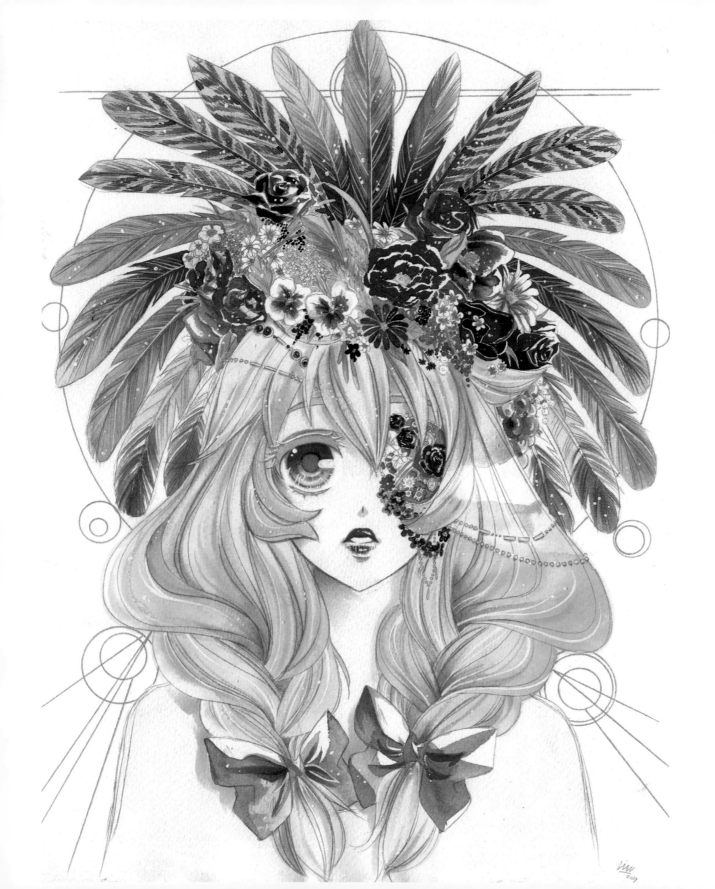

MATERIALS

PAINTS

Different types of watercolor paints.

PANS

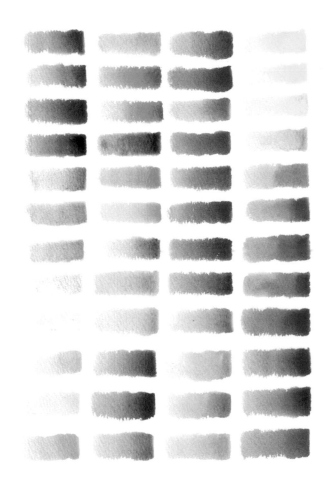

Paints in pans consist of pigments, binders and various additives. They come in half or whole pans. You can buy the pans individually or in watercolor boxes, which usually contain 12, 24 or 48 colors. When they're finished, you can simply replace them by repurchasing them individually, or you can fill the empty pans with watercolor paint from tubes. This way, you can mix individual colors yourself and create your own, very individual paint box. You can even buy empty pans, along with empty watercolor boxes, so that you can design your own box from scratch. You might want to create one with pastel shades as well as your normal box, for example.

WATERCOLOR PENCILS

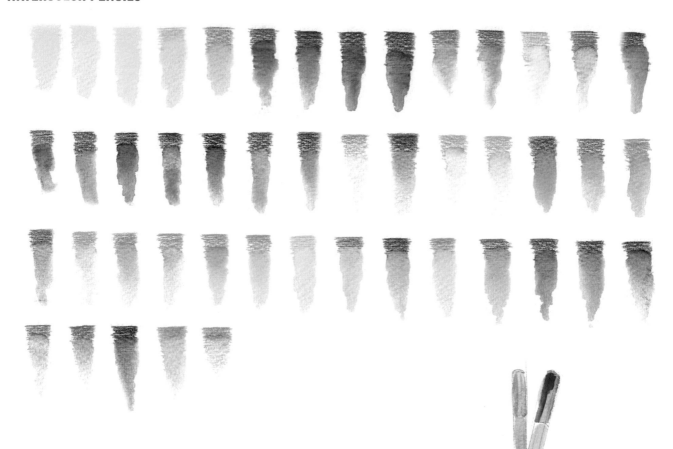

Watercolor pencils can be used like normal pencils but they're water soluble too. You can use them to create beautiful and particularly atmospheric effects when you combine their two properties. Watercolor pencils can be used lightly or more intensely. Their use requires some practice though, as streaks can develop that are difficult to remove. Once you master how to use pencils, however, you can conjure up the most beautiful pictures!

TUBES

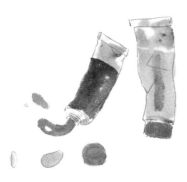

Paint in tubes, like that in pans, also consists of pigments, binders and various additives. Tubes come in various sizes, from 5 to 37ml. They can be used to fill up your pans or directly on a mixing palette. Don't worry if you squeeze too much paint out of the tube, as watercolor paint can be used over and over again simply by re-wetting it. Some artists buy a foldable mixing palette, put a blob of paint on the edge of each mixing area and let it dry out, thereby creating their own paint box from tube paints. If you like working on a large scale, using paints in tubes may be more cost-effective and time-saving for you because getting the amount of paint for large areas out of the pan requires a lot more effort.

BOTTLES

Unlike the other paints, watercolor paint in bottles consists not only of pigments, but also gum arabic, a binder. This means that the paint remains liquid and can be used directly without adding water. You can also use the bottle's pipette for watercolor techniques, such as paint spatters. The paints in

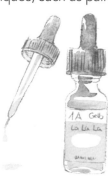

these bottles are very color intensive, but be careful if you want to give away or sell your paintings or keep them for a long time, because they're not light-fast. Sunlight decomposes the pigments

and causes the colors to fade quite quickly. These paints are also tricky to use because they dry quickly and are difficult to reactivate without residues. You can always change the topmost layer, but after application part of the paint immediately settles into the paper and cannot be changed. This can produce the unwanted effect of "overlaying", also known as "glazing" in watercolor painting.

MARKERS

Watercolor markers look like Copic markers or felt pens with a double tip. You can either use them as they are, like watercolor pencils, or activate their pigments with water. However, like the liquid pigments in bottles, they often leave unwanted traces on the paper, which are difficult to remove without residue. You'll always see a small edge where the color first dried out, no matter how many times you wet the spot. As the markers flow seamlessly into each other, your surfaces will be beautifully flat and have none of the ugly, unwanted ridges that you might get with felt-tip pens. These markers behave like normal watercolor paints, so you can use them for practicing your watercolor techniques.

BASICS

Other tools you might need.

MECHANICAL PENCIL

NORMAL PENCIL (HARDNESS B RECOMMENDED)

PENCIL SHARPENER

MIXING PALETTE

BRUSHES

At the start you'll probably find that just three brushes will be sufficient: small, medium and large.

Often the palette that comes in the paint box will be sufficient. If you mix a lot, keep hold of jar lids to use as mini paint-mixing dishes.

WATER GLASSES

It's best to have two glasses: one for washing out your brushes, and one with clean water to work with.

WOODEN BOARD

If you don't have a special place to paint, this is a sensible alternative to stretching your paper directly on the kitchen table (see Preparation)! It allows you the freedom to move your painting at any time and you don't have to quit just because something else is happening at the table. You can simply set the board aside.

TISSUES

WATERCOLOR PAPER

ERASER

STICKY TAPE AND/OR WASHI TAPE OR MASKING TAPE

These materials are sufficient as an alternative to stretching for small illustrations that don't need a lot of water.

TACKS

LITTLE SPONGES

BULLDOG CLIPS

PAPER

What makes good watercolor paper?

Watercolor paper is a must for this type of painting. It's thicker than normal paper and doesn't ripple so easily. You have to be careful to choose the right paper though, as it needs to absorb a lot of water and, depending on the painting technique, sometimes whole puddles can form. Watercolor paper comes in thicknesses from 150 g/m² to 850 g/m² and in blocks, rolls or sheets in all conceivable sizes. So how do you recognize good watercolor paper? The high-quality stuff is impenetrable and easily erasable, meaning there are little to no pencil residues and the paper doesn't flake when erased with a soft eraser. Make sure you don't use an eraser that is too rough or erase so hard that flaking occurs – you'll damage the surface of the paper. This damage leads to unsightly results if you continue using the paper: ugly, unwanted color-runs and build-ups can appear, which often end up emphasizing the damaged area in the overall picture.

TYPES OF PAPER

Watercolor paper has various grains or textures. You can tell at a glance whether the paper is coarse-grained or smooth. The finer the grain, the faster the liquid watercolor will run.

Fine-grained

Working on fine-grained paper isn't easy. You may need to quickly mop up the paint with a tissue, and you'll need to have already had some experience with watercolor paint.

Medium-grained

This paper is perfect for beginners, because you don't have to work fast and can therefore take time to think about your steps. The paints don't dry as fast as on hot-pressed fine-grain paper.

Coarse-grained

With coarse-grained paper, paint quickly pools on the uneven surface and isn't easy to control. As this texture casts shadows, an unwanted effect can arise in the finished image, especially if you want to work in detail. For less-detailed images, such as landscapes, the effect is usually less distracting. You can use this quality to your advantage by integrating the texture into your clouds, treetops or tree trunks.

Tip:
Of course, you'll want to test out for yourself which paper is ultimately right for you. Ask for scraps of paper or test sets from your favorite artists' suppliers. Some stores offer this and are happy to help you find the right material. You can also find mixed paper sets online. I have had many good experiences with matt, coarse paper between 250 g/m² and 300 g/m². It all depended on what I wanted to paint: blocks were too expensive, so I ordered sheets of paper and cut them to the desired format myself.

PREPARATION

Essential steps before you can really get started.

Watercolor paper naturally curls. You can buy blocks of paper that have already been glued round every edge to prevent curling, and you can start painting on these straight away. Sometimes, however, you need to separate the leaves from the block Before you begin painting, I usually recommend sketching on normal paper so that you can make your mistakes without wasting valuable sheets. You'll be more daring too! You then need to trace your sketch onto watercolor paper using a light box or window. To separate a sheet from the block, push a set square under the top sheet and carefully ease it away from the paper below.

ESSENTIAL FIRST STEP – STRETCHING THE PAPER

If you only do small sketches (e.g. doodles), you don't always need to do the extra work that's described to prevent paper from curling. For doodles, I only ever use washi tape to attach the paper. I never use a lot of water, so the paper only curls slightly and automatically lies flat again after drying. If you work with a lot of water, I would use masking tape for doodles. For larger pictures (from A4 size), you will definitely use a lot of water when painting with watercolors, so you need to stretch the paper well first. Only use materials intended for watercolors, as they'll save you from a disappointing result. With wet techniques, neither washi tape nor masking tape will hold the watercolor paper; the

tape comes loose and the paper curls – and remains curled, even after drying. You will need to use gummed tape that is specifically made for the job.

To prevent the paper from curling:

Wet the paper on the reverse with a broad brush (which saves time), but avoid making pools. If some do form, just briefly drain them. Place the sheet with the wet side down on the table or a wooden board. Moisten the gummed tape, pull apart, and secure the sheet. Let everything dry – and you're done! Note that if you use watercolor card you don't have to stick it down – as it's so thick, it won't curl.

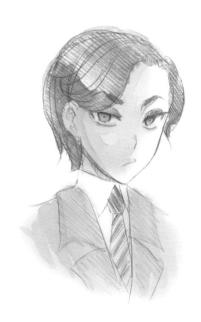

BRUSHES

An overview of quality and handling.

Brushes numbered 8 to 10 are ideal when you're starting out. Depending on the image and level of detail you want to achieve, you can of course add thicker or thinner ones to your kit, but at the start these will be perfectly sufficient. Watercolor brushes have a very thin tip to make detailed work easier. Even medium-thick brushes are suitable for this kind of work. Once the tip has worn out, don't throw the brush away. It will still pick up paint well and is suitable for coarse surfaces or wetting. Keep it for times when the perfect tips of your other brushes would be too good.

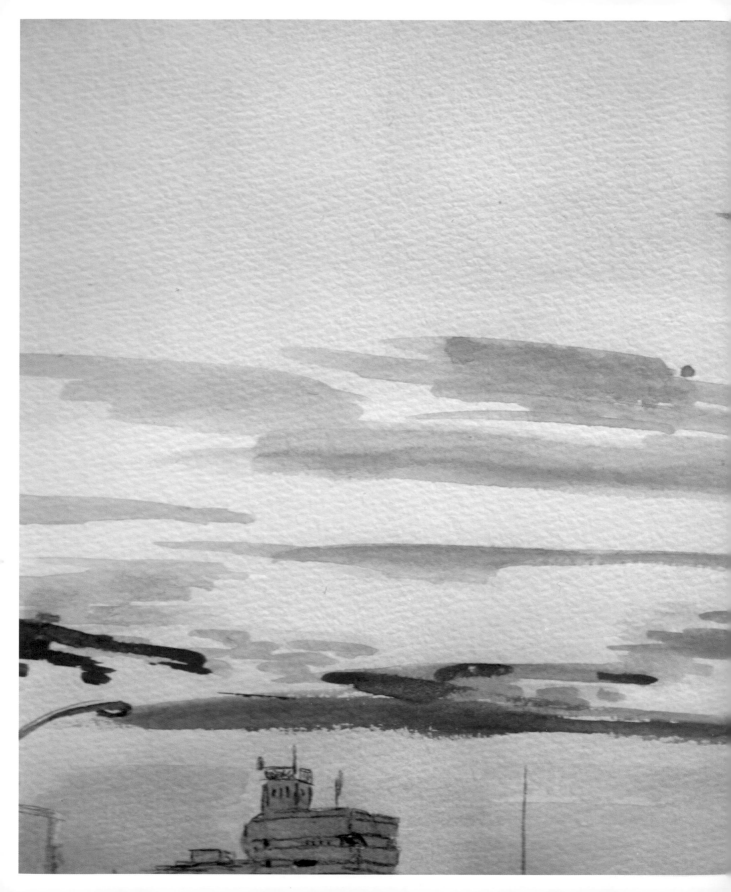

TECHNIQUES

COLOR THEORY

Everything you need to know about the color spectrum, complementary colors and cool-warm contrast.

Harald Küppers' hexagon of colors is the most accurate representation of the theory of color, if you take all the variations on the spectrum of the colors into account, in contrast to the previously used "Itten" color wheel.

He also counts white and black as colors, although they're called uncolored.

In additive (pigment) color mixing:
➡ Green, blue and red are the primary colors
➡ Yellow, cyan and magenta are secondary colors. These are also the primary colors in subtractive (light) color mixing.

The primary colors are positioned closer to black, while the secondary colors are closer to white, as the center of the illustration below shows.

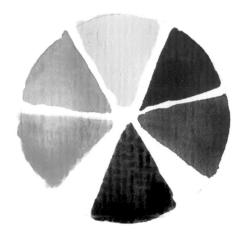

You can read a great deal about Küppers' theory, but briefly it assumes the following basic colors:
yellow / green / cyan / purple / blue / magenta / orange-red.

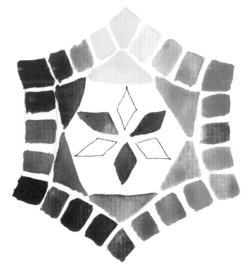

The positions of black and white

COMPLEMENTARY COLORS

These are the colors that are opposite each other on the color wheel. They create a strong contrast because cool and warm colors are brought together, and each enhances the other.

COOL AND WARM COLORS

Cool and warm colors are simple to explain and easy to spot! Paint the well-known color wheel and divide it down the middle as in the picture below. It helps when painting to always have something like this in front of you and to look at it from time to time. The colors on one side are warm colors, and those on the other side are cool colors. You're also touching on the subject of color psychology – how colors make us feel.

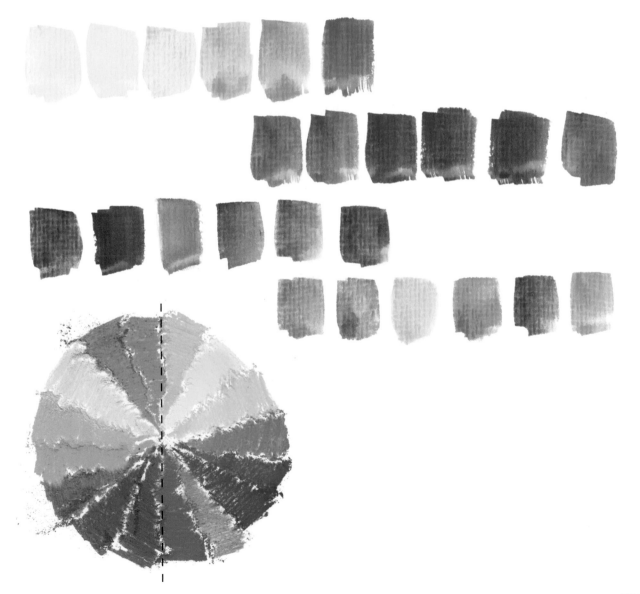

COLOR SELECTION

The color palettes for broken colors and skin tones will help you find the right shade for your image.

BROKEN COLORS

You may be wondering why red and yellow can also be found in the example cool palette, below. If the colors have a certain element of green, blue or gray, they are assigned here. The same applies to cool colors: if the blue contains a little brown or carmine and the green contains a little red, they look warm and are part of the warm palette. As you can see, you can keep consciously breaking the rules and playing with them!

SKIN TONES

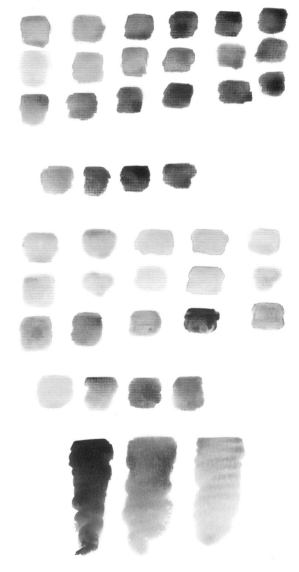

EFFECT OF COLOR

Create mood and atmosphere through the selection of colors.

Just as you need to have control over the water to achieve your desired effects when painting with watercolors, you also need to be clear about the effect of the colors. What do you associate with warm colors, and what do you associate with the cool ones? Of course, you would never use red in a winter picture with snowy landscapes – or perhaps you would? To make images more exciting or interesting, it's often necessary to think a little outside the box. Sure, an ice queen would look better in a blue or gray dress, but if you want to bring a touch of warmth to the picture, you could put a red layer of clothing on your character, for example. Despite the beautiful winter landscape, the focus would fall on them and trigger something completely different in the viewer than if everything were created tone in tone. You're allowed to do anything, but it's much more fun when you know what you're doing and can therefore present your pictures and characters in a more considered way.

EXAMPLES

Here are some examples of the effects of certain shades.

Red:

We associate red with energy, love, passion, willpower, pride and courage. This color is the most intense of all, a signal color.

Orange:

Orange is also a warm color, with which we connect joy, serenity, coziness and energy. Like red, it also serves as a signal color.

Yellow:

This color stands for warmth, optimism, freedom and joy. It can also be used negatively: we associate it with cowardice too, for example.

Green:

We associate green with thoughts of nature, purity, safety, health and freshness. As a cool shade, it can be associated with poison or envy.

Blue:

Is the coolest color. We associate it with ice, solitude, tranquility and melancholy. But it can also stand for respect and trust or balance.

Purple:

The color of inspiration, wisdom, dignity and power. It can also stand for inspiration.

Black:

We associate black with darkness, sorrow, fear and secrets. It can arouse curiosity, appear elegant and fascinate.

White:

White is associated with innocence, purity, cleanliness, order, happiness, lightness and nonchalance. It's considered the most perfect color.

Gray:

Standing above all for neutrality, gray is inconspicuous. It can be associated with a willingness to compromise, but it can also be thought of as boring.

Such strong differences in the effects of color might appear obvious, but a good sense of color does not come solely from a theoretical understanding of the concept. Let's try this out: how does the same image appear, when first colored with completely warm colors and then again with just cool colors? To show you how different colors can affect the mood of an illustration, I'll demonstrate how a face painted with warm colors looks and acts, in comparison to the same image when it's painted exclusively with colors from the cool color spectrum. The two illustrations feel completely different. If you want to try this exercise yourself, you'll find details in the project "Girl's face with expressive eyes" later in this book.

BASICS

The art of breaking everything down to basic structures.

In order to be able to paint pictures, we have to observe and analyze. Painters and artists often see the world a little differently – more intensely than their fellow human beings. One of the Old Masters, Peter Paul Rubens, summed up long ago something that we should always hang on to in the backs of our minds when drawing: that the basic structure of the human form can be traced back to cubes, circles and spheres. Paul Cézanne later extended this idea to all objects in nature. No matter how complicated your image or object seems, everything can always be broken down into its basic forms. Think about it, start sketching and try it out. You'll see, it's pretty easy!

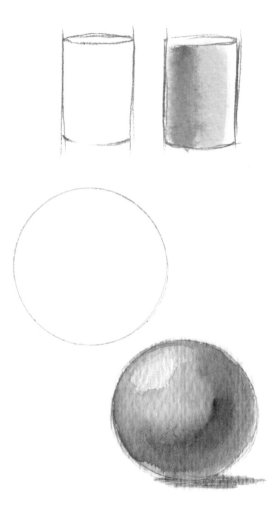

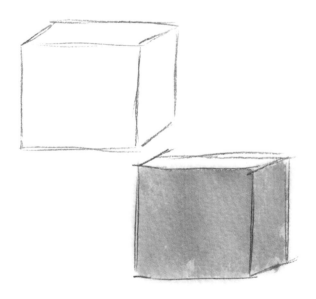

You can practice this method of analyzing complex shapes in the simplest of ways. Detailed and elaborate pictures are just embellished basic forms, and it's with basic forms that we start in this book (see Doodles for more examples)!

PROPORTIONS

MAN

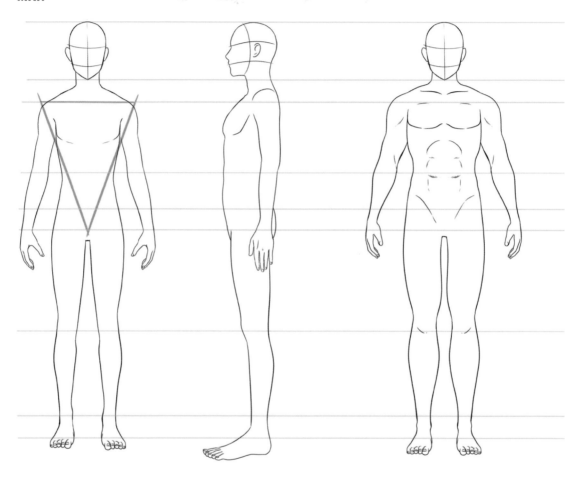

Basically, no two bodies are alike, but in manga you often develop a specific body type that runs through your style. Even when I draw thinner or fatter people, I always use the average shape as a guide by starting with the body as I normally draw it. Then I add a little more "mass" to certain areas, such as the abdomen or arms, or take a little away.

For men, it's easier to imagine a triangle with the tip pointing down. The same principle of simple forms applies here: this is only the basic shape. Men can appear androgynous in manga. You can also give this body shape to a muscular woman if, for example, you want to have a tough commander in your story. There are no constraints on your imagination.

WOMAN

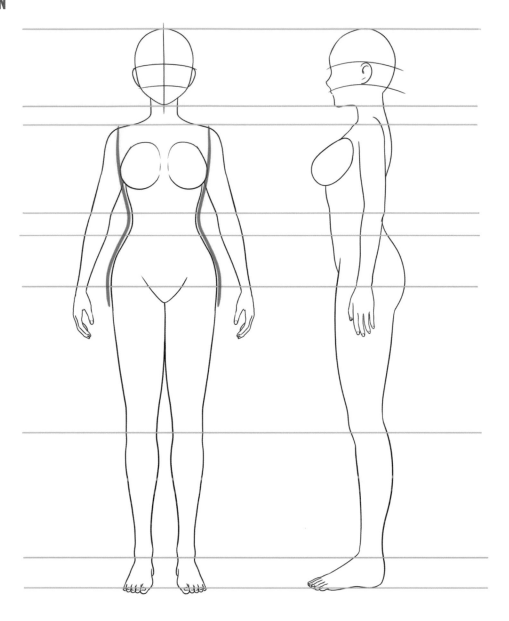

The body of a woman is more like an hourglass in its basic shape. For some women this is more pronounced, others less so. Draw whatever shape you like the most. You can use manga to make a statement about body image or alternatively, don't take the whole thing too seriously. Manga and illustration thrive on exaggerations, and thus this style can be used for many things.

CHILD

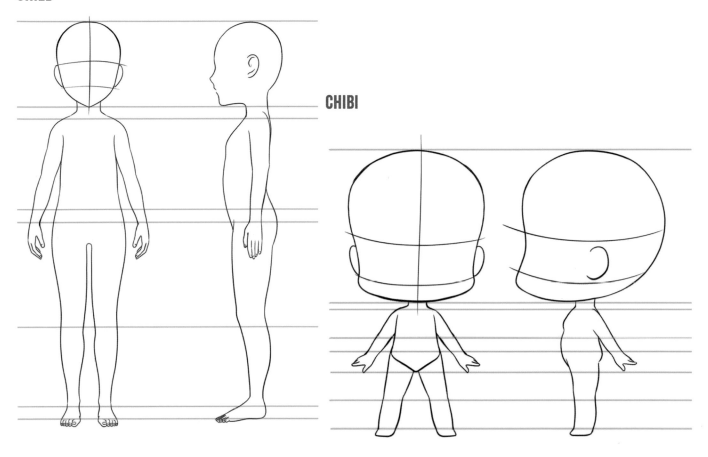

CHIBI

Children are not as advanced in physical development as men and women, and therefore the physique of boys and girls is similar. I omit gender characteristics for obvious reasons. Children in manga are defined by narrow shoulders and a slightly wider pelvis, as well as a large head. If you go one step further and draw a chibi (slang for someone small and cute), you'll disregard almost everything you've learned about the proper drawing of bodies. All you'll need is a head, torso, arms, legs and maybe a short neck. The head is oversized in relation to the body; the arms and legs are shrunk to a minimum. There are hundreds of styles for drawing chibis. At the end of the day, it's all about whether you find your chibi cute or not. Some artists draw their chibis' arms and legs so short that the joints are no longer recognizable, but that's perfectly okay. After all, this is about maximum cuteness, not correct body shapes.

FACES

ADULT MAN

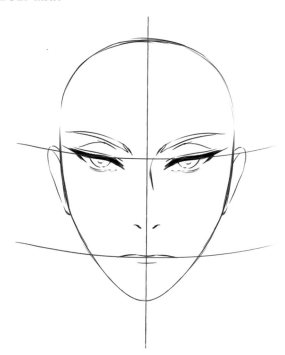

YOUNG WOMAN

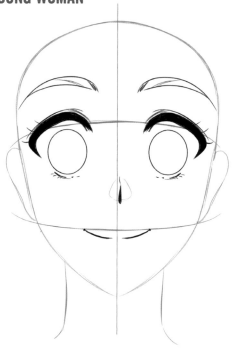

Practicing faces is a kind of perpetually ongoing task. Even as an experienced manga artist, you can never practice enough. It helps to look at how others draw certain things too. Your own illustration style first shows in the faces you draw, but will probably change throughout your life.

Be aware that certain figures and their character are expressed by the shape of their face alone. Adults between the ages of 30 and 50 often have slightly longer faces in manga than children or adolescents. If you shorten the chin a bit or draw it wider, you can make the character a few years younger.

ADULT MAN

YOUNG WOMAN

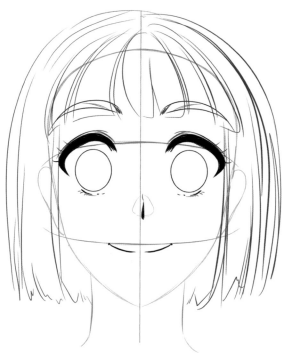

CHIBI

I often draw the hair around the face generously. Make sure that you always imagine the hairline when you do this and draw your hairstyle from there. The bangs (fringe) should fall from a reference point.

I always imagine the height of the forehead and work from there, especially with men. With chibis, I often simply draw an exaggerated, voluminous hairstyle,

paying attention to the bangs and the parting. Certain basic rules need to be observed so that the character doesn't appear strange. Manga is based on the real world, and if you want to conceptualize something like a hairstyle (a common practice in manga and comics), you first need to understand how things are structured in reality.

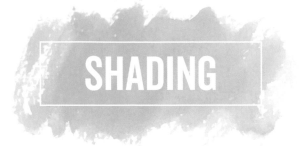

SHADING

How to shade correctly by positioning the light source and choosing the shading color.

LIGHT, THE COLOR OF OBJECTS AND SHADING

There are many ways to make your image more interesting and to "take it to the next level". Creating shading isn't done by adding gray or black alone to a color to make it darker. You'll slip into a murky gray palette very quickly as all of your colors will have this look and, in the end, your whole picture will look a bit muddy and dirty. Sometimes, such an effect is intentional, but usually for beginners it happens out of ignorance and is frustrating. The image looks lifeless and something bothers you, but you just can't figure out what it is. Believe me, in 90% of cases, it's down to the way you chose the shading color. Learn how to avoid such mishaps by paying attention to the ambient light. If your object is in a meadow, use green and yellow in with the gray of your shading. In a room with violet light, mix in pink and purple. Outside in nature, choose blue. Feel the intensity of the shading too. Sometimes it can be refreshing when the shading stands out due to its glow; sometimes with just a little light, a mere hint of a hue in your shading is sufficient.

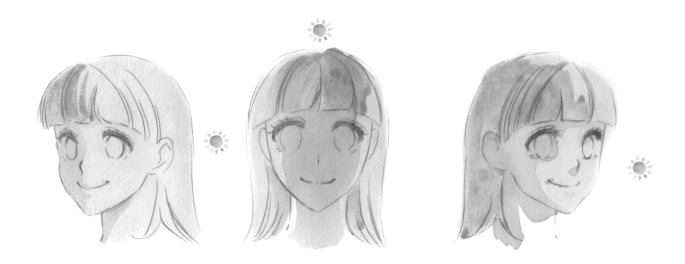

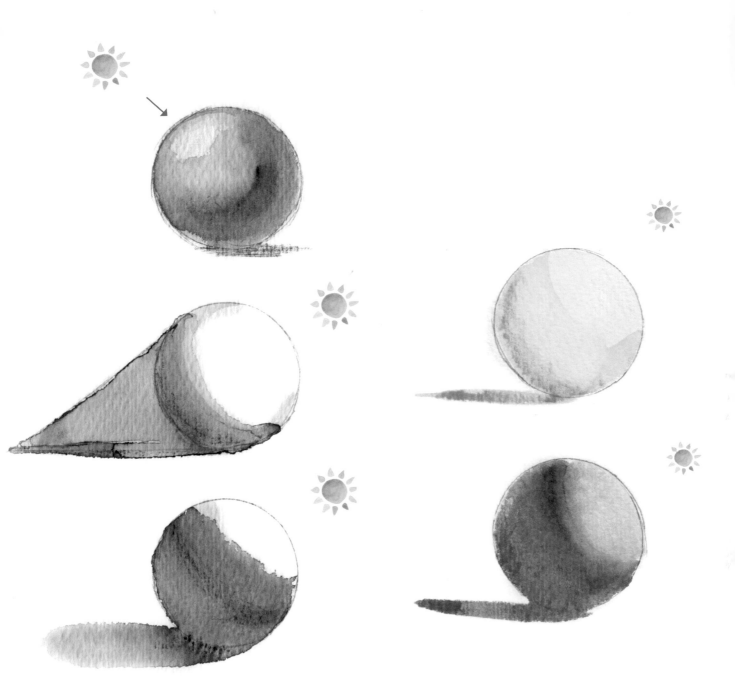

SKETCHING

Whether working digitally or by hand, the sketch is the framework of your image.

When you draw, you must also draw the lines that won't be visible later. Guidelines are essential, helping you to avoid strange perspectives or slipped body parts in the final picture. You only need to mark them faintly. It's just important for you to see that the object or body continues there. You may think that this goes without saying, but believe me, it's completely different when you can see what you're working towards. When the sketch is finished, you can erase the guidelines. If you're working on screen, it's possible to create this layer digitally and then simply switch it off. For work by hand, I recommend a pencil eraser with which you can work very precisely. Since I usually sketch digitally, I have to transfer my image to watercolor paper using a light box.

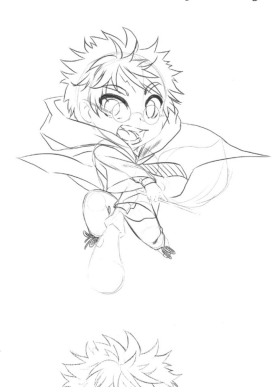

Tip:

If you don't have a light box on hand, use your window! If you work by hand, I recommend that you don't draw the sketch initially onto the watercolor paper (except for simple images, such as doodles). You'll immediately feel under pressure not to erase too often, as this damages the paper and reduces its quality. If the surface is too damaged, it no longer works as it should, and there's no way you can repair your picture. Whereas, on normal printer paper, you can try it out and indulge yourself with as many corrections as you like.

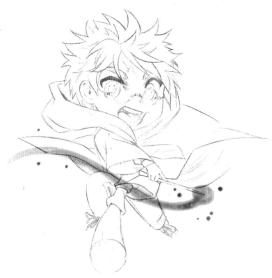

WET ON WET

With washes you can create gradients with a paint-water mix.

Now that you know the basics in terms of colors and have got a feeling for how they work, we'll specifically use this knowledge in combination with the following techniques.

WET ON WET TECHNIQUE

➡ atmospheric

➡ smooth transitions

➡ fading colors

➡ wetness of the paper determines the degree of color gradient

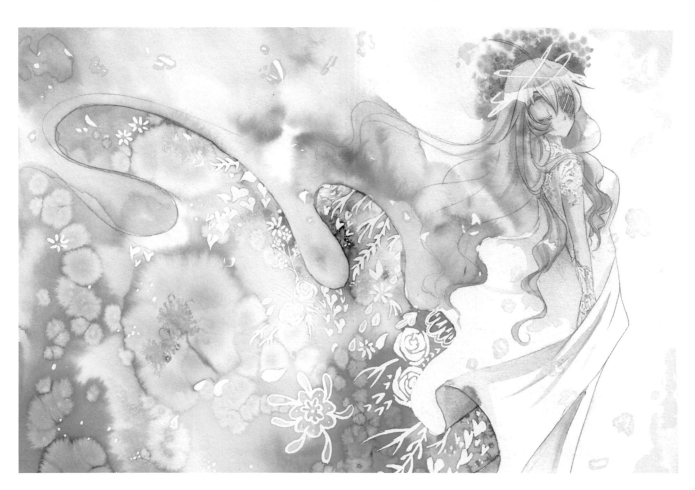

Before you start, you should have a rough idea of your finished image. Will the background be blurred and distant? Will you draw your subject in detail and keep the background quiet, or create a cool or warm mood? The further away an object is from us, the more blurred we perceive it.

The easiest way to use the wet-on-wet technique is with wide brushes or sponges. As the name of the technique suggests, you paint using a lot of water in your mix and paint onto wet paper. Make sure that the water does not form pools on the paper.

You're conveying this feeling on paper and giving the viewer a touch of reality in your work. Now let's deal with the middle ground, which should be more detailed and can be seen more clearly. Wait for the paper to dry. This is important to enable you to paint the exact shape you want in a controlled manner.

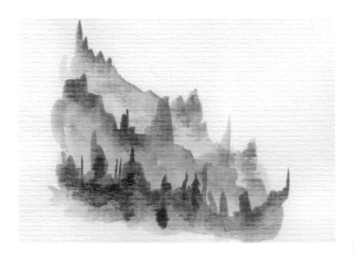

The paper should look wet as on the right side of the photo above. As soon as pools form (as shown on the left), there's too much water. You can brush it off, dab it with a towel or tissue or simply draw it up with a pipette until the pool has gone.

DRY TECHNIQUE

With glazing (applying paint by layering) you can create semi-transparency.

The dry technique is a very controlled way of painting. There are only a few rules to follow (e.g. the distancing of objects or landscapes), otherwise you are completely free to try it out and just paint! However, this technique is also suitable for somewhat larger areas such as clouds. Remember to test out in advance whether you can continue to paint on the white surfaces created by watercolor paint, or by gouache or opaque white. Some colors repel watercolor paints

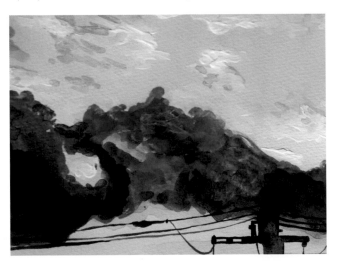

or absorb too much or too little color. You should be aware of what the wet-on-wet and dry technique can do in each case, and select them accordingly. Mostly, you'll be mixing techniques, and through practice and experiment, you'll soon be able to master them.

WHITE AREAS

Use the white of the paper or create a white surface with opaque white, acrylic paint or gouache.

WHITE AREAS AND BLANK SPACES

White does not normally exist as a color in itself when painting with watercolors. Instead you use the paper or various techniques to incorporate the white of the paper. By applying paint and leaving areas blank, white areas are created automatically. Manga illustrations are often full of detail, and it's difficult not to paint over certain areas. Sometimes that's no bad thing, as it looks casual and playful when you paint over here and there. Painting in watercolors is supposed to be fun, so just make the most of supposed mistakes, or as Bob Ross said, "Happy little accidents!" Before you start painting, you need to be clear about where the light source is and what techniques you can use to make it as easy as possible to put what you're thinking onto paper.

There are several options: opaque white, gouache and white tempera. One option I would like to introduce you to, especially for smaller areas, is the use of opaque white. You can use different types, and that sometimes involves a bit of trial and error, as one white isn't the same as another. Some opaque whites are not as opaque as they'd seem, whilst others, such as white tempera, are true opaque paints. For manga illustrations, I usually use opaque white, white acrylic paint or gouache just for the eyes or small highlights on the clothes or face. Another way to create white areas is to use masking fluid (more on this on the next page). You can also create white areas by removing paint using a (wet) brush, tissues or toilet paper.

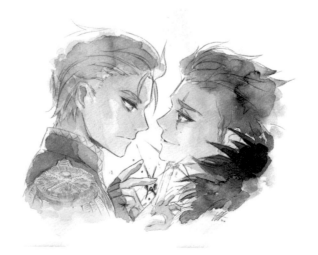

SPECIAL TECHNIQUES

With these techniques you can create great effects and set off your image perfectly.

MASKING FLUID

Masking fluid can be found in bottles, or in pens with tips of various thicknesses. You can apply it directly onto the white of the paper or onto dried paint and then simply remove it later by carefully rubbing it off. It's best to use 250 g/m² paper, because the masking fluid can sometimes prove to be a bit stubborn to remove and thicker paper is less likely to rub away. Masking fluid from a bottle is applied using a brush. I always have two brushes ready for this: a narrow one for details and a slightly wider one for large areas. Clean the brushes immediately after use, otherwise the liquid gum will become hard and you'll no longer be able to use the brushes. You'll never get everything out of the brush, so use synthetic brushes for this job. These can be bought cheaply, however, do make sure they haven't already started losing their bristles in the packaging, otherwise they will only be a nuisance when you work with them later. Masking fluid dries very quickly. Afterwards, you can paint over it easily and as often as you like, as nothing will leak through and color your desired white area. Once your watercolor paint has dried, you can remove the gum.

FILM TECHNIQUE

Another technique that you can use in a variety of ways is the film technique. It's very effective, for example, for creating a pattern. Make sure that your paint isn't so wet that it forms pools, otherwise you'll have to wait a very long time for the result to dry. The beauty of this technique is that you can adjust your pattern however you like. You just put the film on your paint, push and pull it around and then wait a few hours. I usually allow my pictures to dry overnight to be on the safe side.

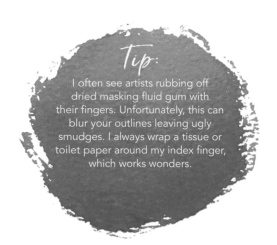

Tip:

I often see artists rubbing off dried masking fluid gum with their fingers. Unfortunately, this can blur your outlines leaving ugly smudges. I always wrap a tissue or toilet paper around my index finger, which works wonders.

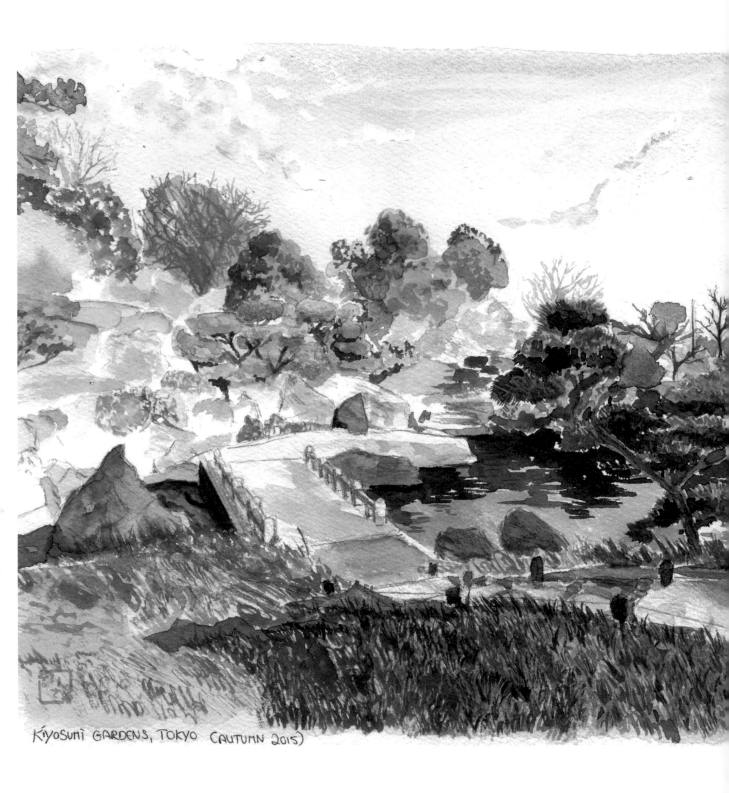

KIYOSUMI GARDENS, TOKYO (AUTUMN 2015)

EXERCISES

GRADIENTS

Practice the wet-on-wet technique by experimenting with color gradients.

Repeat the following exercise with two or three different colors: wet the paper, draw a horizontal brush stroke at the top edge of the paper, and pull the paint down with the brush until it fades to white. Wait until the paint and paper have dried. For a more intense effect after drying, repeat the same process with a second solid color (see picture below right). Painting with watercolors is meant to be fun, and despite the rules that exist, you should also try things out for yourself as much as possible. Take your time and play with the paints to see what they do to each other and the effect they have. The easiest way is to use the wet-on-wet technique and a few overlays. Throw caution to the wind and see what happens. This is how you improve your sense of color! For inspiration, here are a few examples of beautiful gradients:

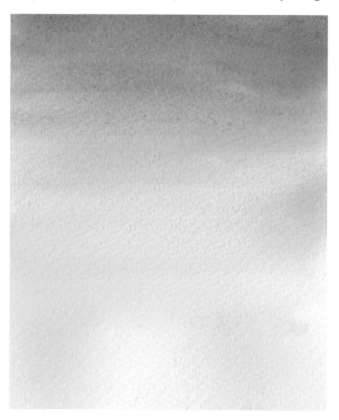
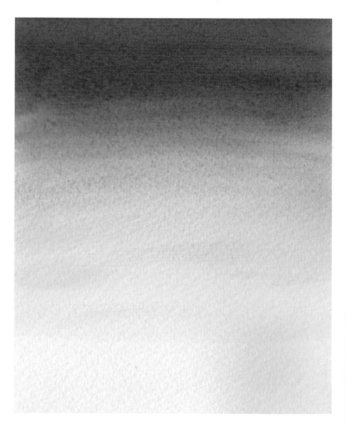

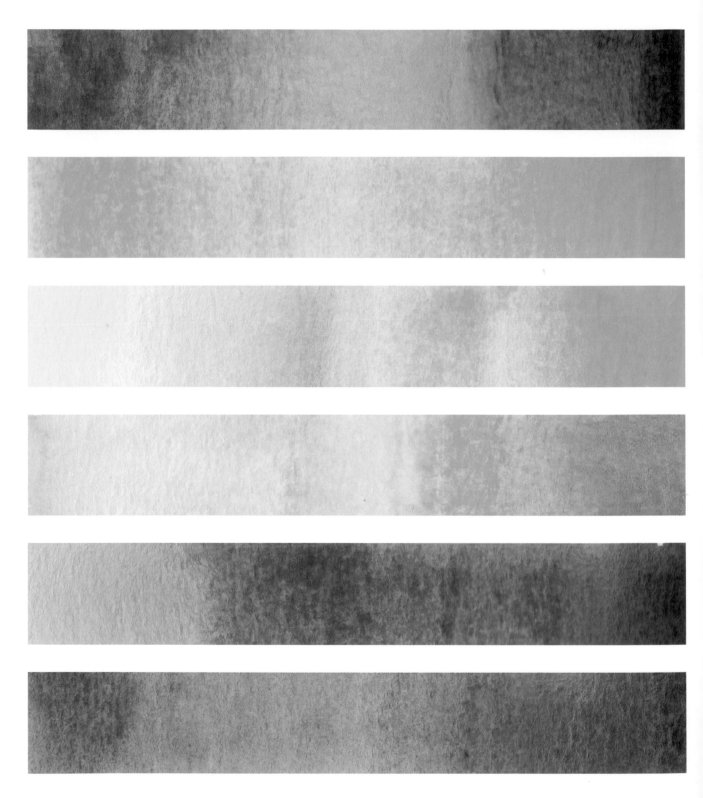

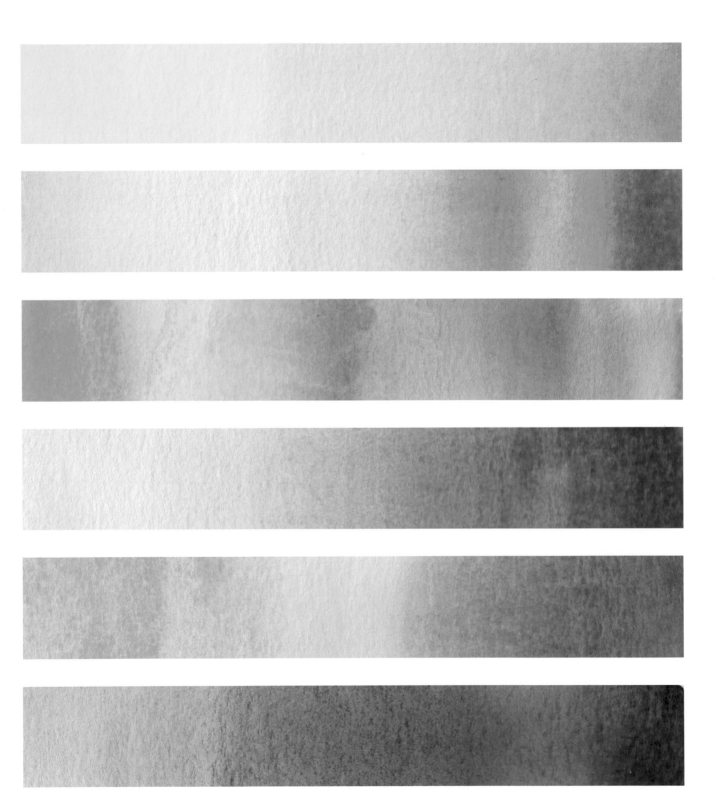

DOODLES

Doodles are sweet little scribbles that are great for practicing painting with watercolors.

BASIC SHAPES

You can do a lot with just basic shapes and keep yourself endlessly busy. Practice makes perfect, and you'll be amazed at how quickly you get a feeling for drawing shapes if you sketch little things from time to time. Often you see a picture and think, "I could never do that!", because maybe there is a lot of detail or the color is quite breathtaking. But every artist practices a lot, and what you're seeing is the result of this hard work. You can get a feeling for objects and their construction through doodling, and you can put that knowledge to use later, e.g. in backgrounds, or when creating your bullet journal, or for a collection of pretty cards.

SHIBA (BREED OF DOG)

You can quickly conjure up a sweet Shiba from
a circle with ears!

GHOSTS

Or create ghosts in different shapes and forms. If the circle
you've drawn is a little bit stretched and not quite round – no
problem – you can just have different types of ghosts! Try
to distance yourself in your head from rigid shapes, and use
your "mistakes" as a chance to create something new. That
way, your doodles won't always look rigid and the same.

ELEGANT TEACUP

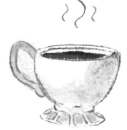

Even seemingly difficult items like
cups are possible if you break them
down to their basic shapes.

KOI CARP

CRESCENT MOON

STARS

PAW

ICE-CREAM CONE

FUNNY BUNNY

BOOK

ORANGE

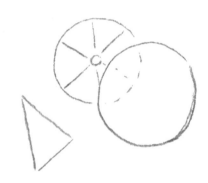 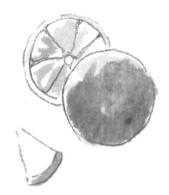

ONIGIRI (RICE BALLS)

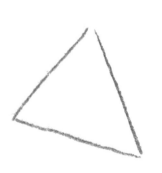 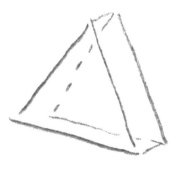

TEA BAG

CANDLE

CACTUS

SPOONS

BABY OCTOPUS

CUTE KITTEN

JAPANESE FOX MASK

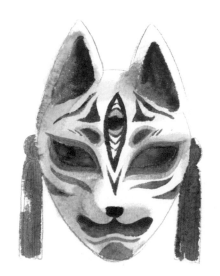

PIZZA

DONUT

HOUSEPLANTS

WITCHING HOUR

The more confident you are, the more you can combine
doodles, and tell stories using little pictures!

GEMSTONES

The surfaces and textures of gemstones can sometimes be a bit complicated. With these you need to break everything down into its basic shape in your head, then it'll be much easier to achieve.

Here the large octagon in the middle is flat, so the sparkle and reflection are different in relation to the corners around it. I drew a few diagonal lines there and it already looks like an area that is directly facing me. At the edges, I changed the angle of the lines, because these areas slope away a little more from the center, reflecting and refracting light in a very different way to the large, central surface. For variety, you can draw some sparkle along the shape here and there (such as in the top right corner of the stone). The lines follow the cut of the inside shape. As you apply the base color, think about your light source and leave white areas blank. This creates the impression of sparkle. As you can see, I used my guidelines to arrange light and shadow.

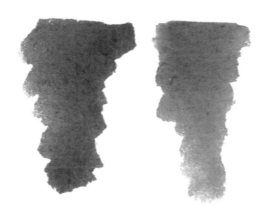

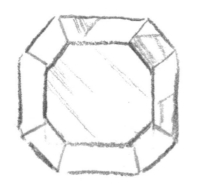

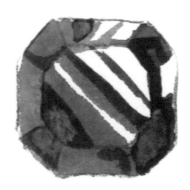

A common form of gem is the teardrop. For this, rather than making the outer and inner shapes the same, start by drawing the central inner shape, as in the first example below. Your basic structure is kite shape, around which you can then sketch the outer teardrop shape. Remember to leave a gap, because there will be a lot happening between the inner shape and the outer shape.

Continue on the lines from the points of the kite shape to the outer edge. This is how you define the final shape of your cut.

To make all of this clearer, as in the first example, draw guidelines again to further clarify the shape and indicate the cut. The light usually refracts at the center top so I put another point there and drew a few lines to represent the refracted light.

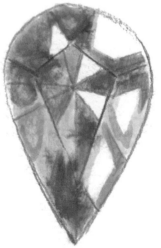
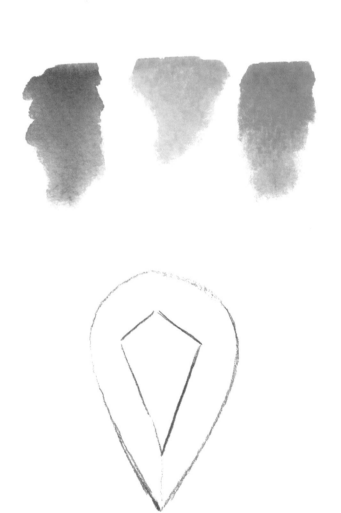
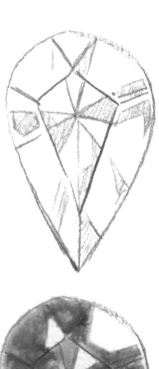

Feathers can be colored in hundreds of different ways, depending on how you perceive them. You can paint them realistically or you can conceptualize their shape. For something with such a large area, you can let your imagination run wild. Be creative and paint a portrait within a feather, for example, or play with different watercolor techniques.

The basic shape is always similar but, depending on which technique you use, your lines will be harder or softer. Sometimes hard outlines are jarring and it's enough to just hint at them. It's often difficult to get rid of the pencil drawing afterwards, so think about the desired result beforehand.

I wet the first three feathers (opposite) and created gradients using the wet-on-wet technique. For the pink feather, I applied color then removed a few strokes with water and a clean brush to improve the shape.

The blue feather was given an attractive color gradient by sprinkling a little salt on the shaft. The wide feather is an earthy mix of black and brown. The outlines of the left-hand feather stand out strongly. I also wanted to make this feather a little more realistic, which lends itself really well to manga.

After drying, I painted the vane of the green feather with a few more strokes, starting from the shaft. This is how you make the finishing touches. Make sure you don't add too many dark lines, as you can quickly take away the lightness of an image. I decorated the brown feather with patterns, sticking to earthy tones, so that it didn't become too colorful. This is just my personal preference, of course. You can give your imagination free rein!

With the blue feather, I wanted to convey a cool and frosty mood, so I only defined the shaft a little.

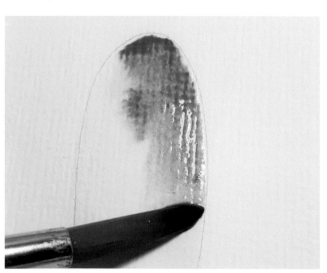

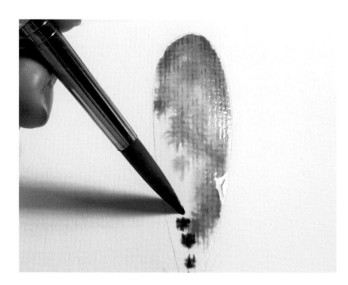

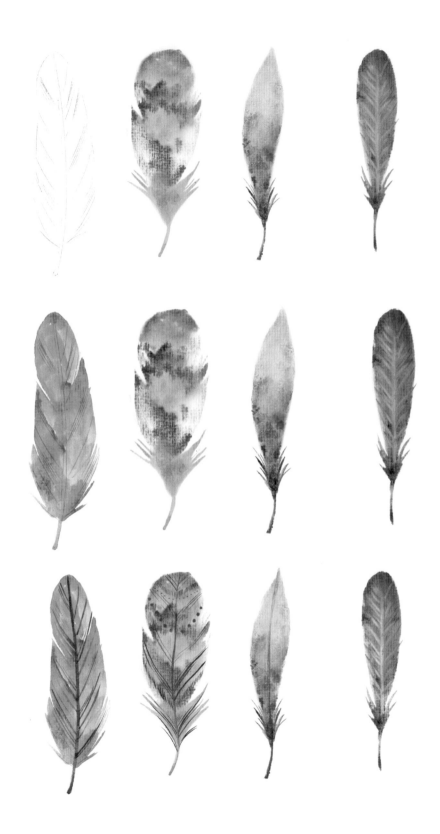

SNAKESKIN

1 Snake scales are very easy to draw once you understand their basic structure. First draw a grid (in this example, it's simply a little rounded). If the scales are on a snake, follow the shape of its body with the grid lines. Now you have your guide and you just have to tweak the shape to fit the snake.

2 Next I erased the grid a little bit, because it's only acting as a guide. The lines were touching to begin with, but after a little tweaking the grid becomes more like an area of rectangles.

3 I then worked inside the rectangles. By this stage I had a kind of grid again, but this time defined with wider gaps between the rows. Again, because I felt it needed it, I added a few strokes here and there to make the scales look more real. Very few objects and surfaces are completely smooth.

4 I shaded my gaps with a reddish brown. I painted the scales blue, together with a darker mix of blue, making sure that they weren't painted perfectly and weren't too covered. The result is a pattern that looks grimy and dully metallic.

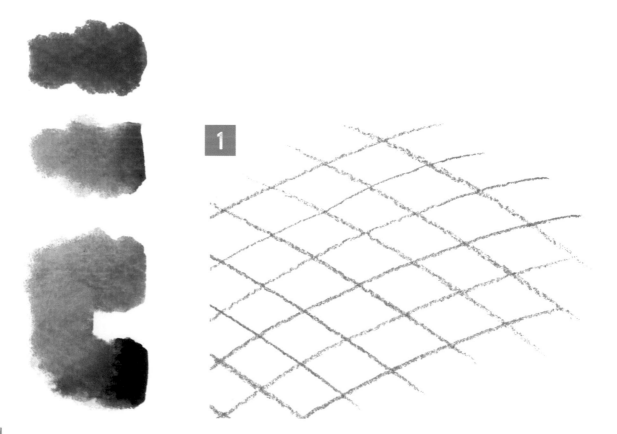

1

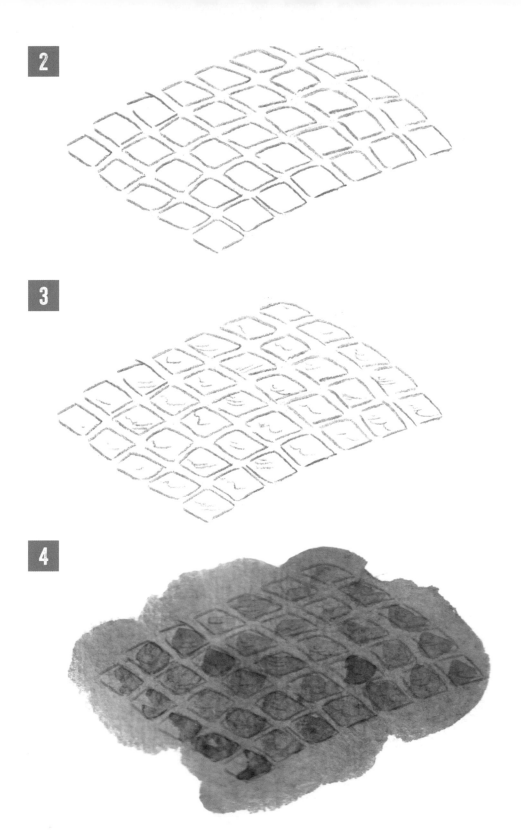

DRAGON SCALES

1 Dragon scales begin with a grid of rectangles that don't quite close up to help as a guide. Leave some gaps. Remember, the grid is only used as a guide and doesn't have to look perfect.

2 I then drew the scales in the desired shape around each of the rectangles. To do this, I imagined a rough teardrop shape, which disappears beneath the row of scales below, leaving only the top part visible.

3 Next I put a few lines on almost every scale to make them look more realistic and aged.

4 I shaded the spaces between the scales, making them more 3D.

5 I set the base color using green, with a few highlights in yellow. Painting a shadow makes the scales look even more real.

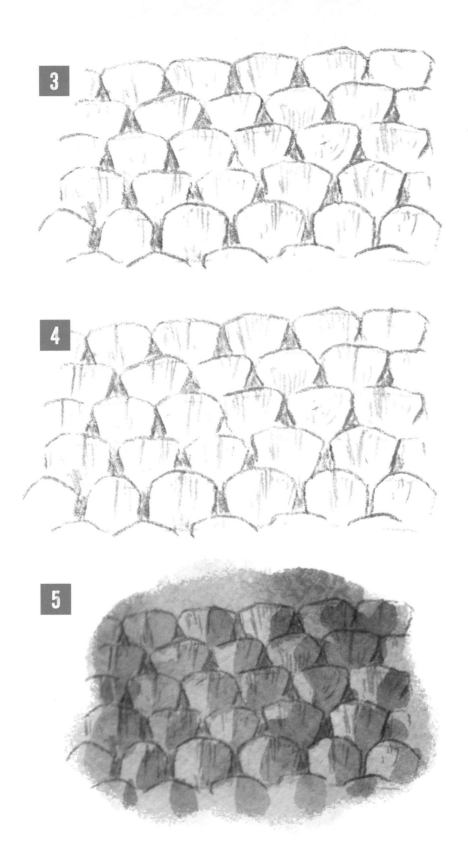

WALLS

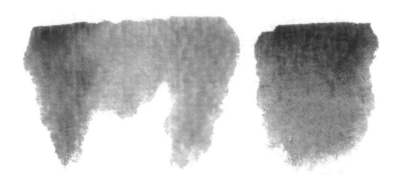

1

1 The basic structure of a wall is a simple grid. I never press too hard with the pencil when drawing this, because it's mostly only a guide that will either be erased or become blurred by constant overpainting, thus disappearing.

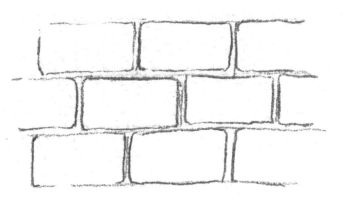

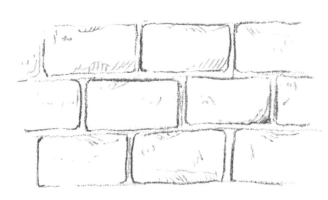

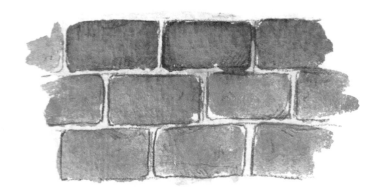

2 Take a look at some walls. One brick never sits directly above another. The mortar connects them, so leave some distance between the bricks. Simply use the lines of the sketched grid as a guide.

3 To make them a little more exciting, after laying down the watercolor ground (base color), give the bricks some texture. A few lines here, a few dots there, and you get the impression of masonry.

4 The coloring can easily get a bit messy. With textures, this can enhance the effect, and it fits perfectly with the look of walls! Don't forget that stones aren't just one color. I mixed in some green and blue with the basic reddish brown.

WATER

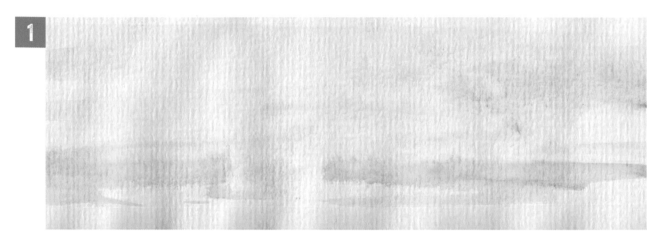

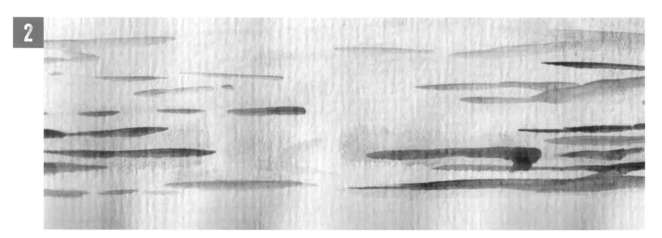

1 You can use the wet-on-wet technique as a way of achieving a blurred watery effect by dragging the color from left to right. In so doing, you can create an impression of depth. Using this technique, the water appears to be further away from the viewer.

2 If I add details that define the water more, this creates the impression of the surface that feels closer to the viewer. You can then keep adding a little more definition to the water surface.

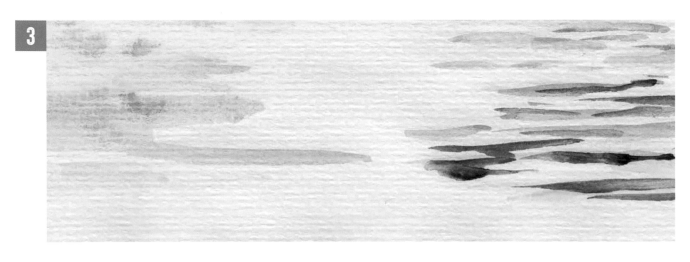

3 How much detail you go into depends on how distant the water is. This is also how to mimic the look of moving water. Bear in mind that water has many colors depending on the light and landscape. You could use a grass green as a base and then add texture with turquoise, which is also a way of creating mood. Always use some of the colors of the sky when painting sunsets as they will reflect.

4 When it comes to the look of the water, make sure you don't just draw short lines, but draw a varied pattern with connected and unconnected lines. Water is one of the most complex things you can paint. Don't be put off by something that doesn't keep still. Remember that when using watercolor, you don't have to copy exactly. Paint what you can see and with whatever technique is available to you.

TREES

All the textures of nature can be defined using various painting techniques. Trees might require you to combine several of them!

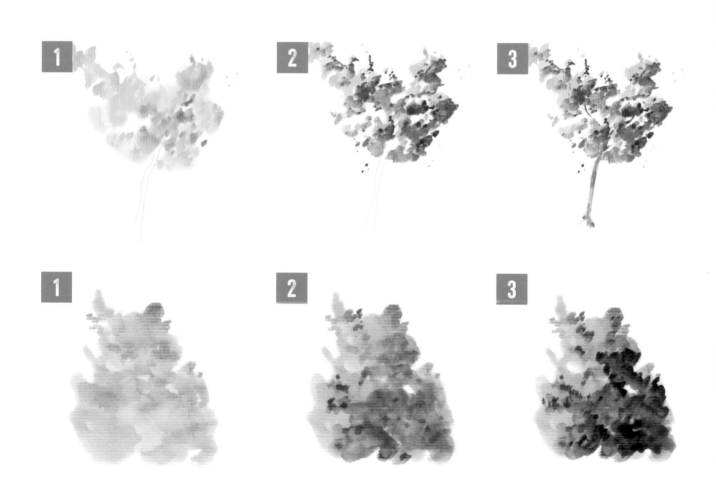

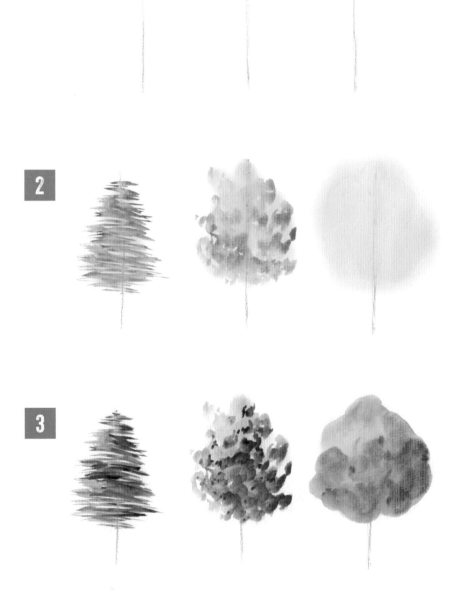

Use what you have already learned in this book to create a range of tree types. For example, you could use the mixed wet and dry technique or use just one of them. There are so many ways of expressing yourself. Finding your own painting style means using the techniques that you enjoy the most. By using a combination of different techniques, you can develop your own unique style.

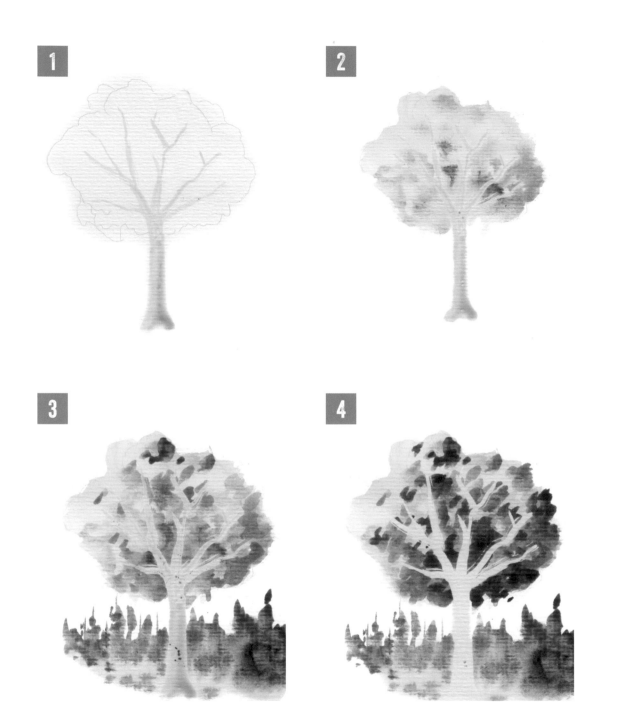

You can, for example, use masking fluid, as shown here, and take a completely different approach. When you use masking fluid for these techniques, bear in mind that the best way to make the masked parts stand out is to use dark colors around your lighter areas. The darker you color the bushes and trees and use the masking fluid around them, the more the actual tree stands out at the end.

You can also use this technique for less detailed styles that you might decide to draw.

If you want to discover more ways to draw trees, just look at the landscape exercise on the following pages.

LANDSCAPE

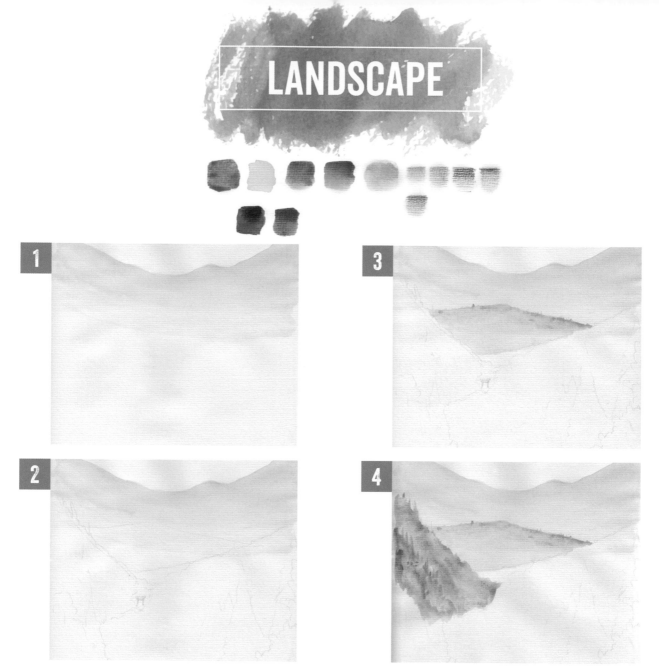

1 For distant mountains, use a light green to wash a few peaks in the background. It's fine if the contours blur a bit – distant things naturally appear blurred.

2 The background will determine the height of the mountain range. Use watercolor pencils for guidelines, which will blur when they come into contact with water and watercolor paint.

3 I positioned the forested mountain in front of the most distant mountain range, so that the wash of the first mountain looks like fog. The more lightness you achieve, the foggier it looks. This creates a 3D effect.

4 The closer the mountain was, the more I used the wet-on-wet technique to create small peaks, giving the impression of a forest.

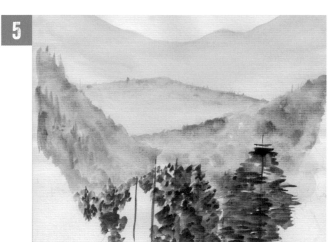

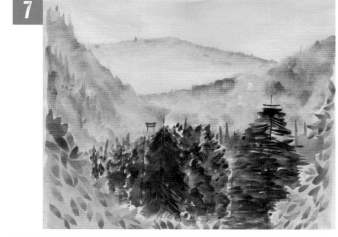

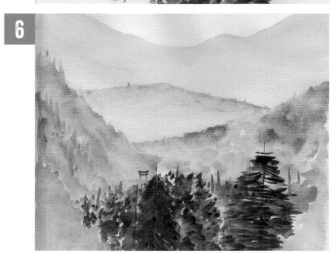

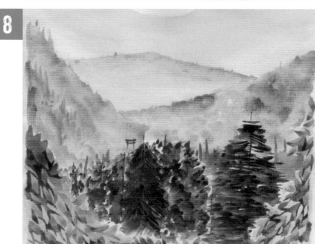

5 After the mountains had been painted, the trees in the foreground came next. They have to be more detailed than the background, so I painted them with less water and defined the treetops more. Look at the Trees exercise earlier in this book for ways to use watercolor to create trees.

6 The small hill in the background remains just an impression without any painted details, so that it continues to look far away. It should just be a dash of color in the landscape. Next I started to fill in the foreground with a light wash of pale blue-green, using the wet-on-wet technique.

7 I defined the individual leaves in the foreground and gradually created the texture of the bushes.

8 Using the dry technique, I filled the gaps with dark color. It doesn't have to be opaque, but it has to be a few shades darker to create the feeling of depth. As the name suggests, the paper is dry. You will almost always need to combine the wet-on-wet and dry techniques, so it's important to master both.

You can use gouache to add eye-catching detail and color to your watercolor paintings. You don't just have to use it for clouds! In the Disney studios, artists have been working with it for a long time. Unlike watercolor, with this medium you don't work from light to dark, but from dark to light. The paint is very opaque and allows you to create your images in the reverse way and make them appear really vivid.

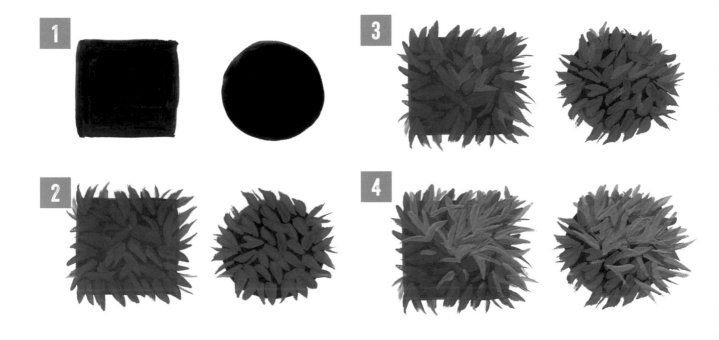

1 Paint a dark shape as the starting point for foliage. I used a very dark green here; you can also use black.

2 With the first layer you define the leaf type. You can paint smaller or larger leaves.

3 I defined some highlights next. You can add them later, but it always helps me to see the shape of the drawing a little more three-dimensionally. The sooner I see this, the better I can align the rest of the coloring with it and stick to it. I now know that my light source is in the top right corner.

4 Finally, the lightest leaves are added. Make sure that closest to the light source – in this case at the top right – most of the leaves are light. Depending on the shape of your starting point, they should become progressively less light further away from the source.

HAIR

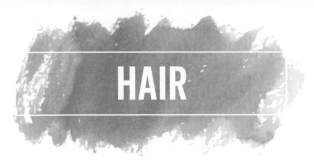

Of course, you can color hair in many ways. Here are just some of the huge number of possibilities available with watercolor.

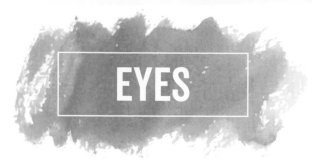

EYES

Large, expressive eyes are characteristic of manga illustrations. Light reflections and highlights add the finishing touches.

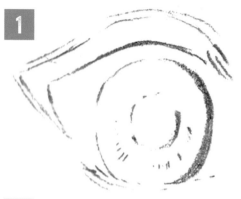

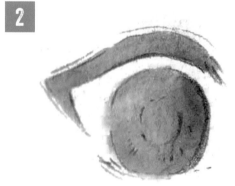

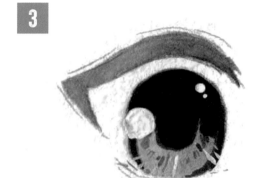

1 First sketch the shape of the eye to suit the character you are drawing (see Faces).

2 Start with the lightest color and apply it once, all over the iris. If you leave the central pupil unpainted, an edge may form later where the iris color meets it. This can look beautiful, but it can also be annoying. You can give the eyelid a sweep of gray to define the eye at this point.

3 When the paint has dried, apply a darker red, i.e. a medium tone between the first color and the dark red you will use at the end. A few strokes on the iris give some detail and the color prepares the iris for the next step. After drying, I went over the inner edge of the iris finely with dark red, and then I did the groundwork for the pupil. Be careful not to overpaint all of the medium tone, but let it show through very slightly. Set the light reflections last, using white gouache. Pay attention to the way the light falls. If the face you are drawing is in shadow, there will only be very pale highlights, or no reflections at all.

Eyes in manga are based on reality. This means that you color the iris and pupil following the basic shape. Depending on the style, artists also emphasize the lower lid, the upper eyelid, eyelashes or tear ducts.

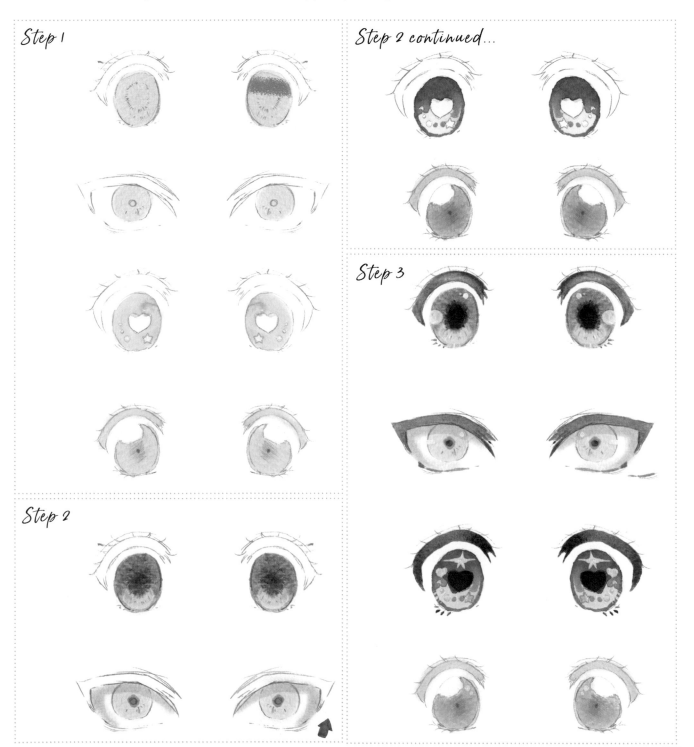

Step 1

Step 2

Step 2 continued...

Step 3

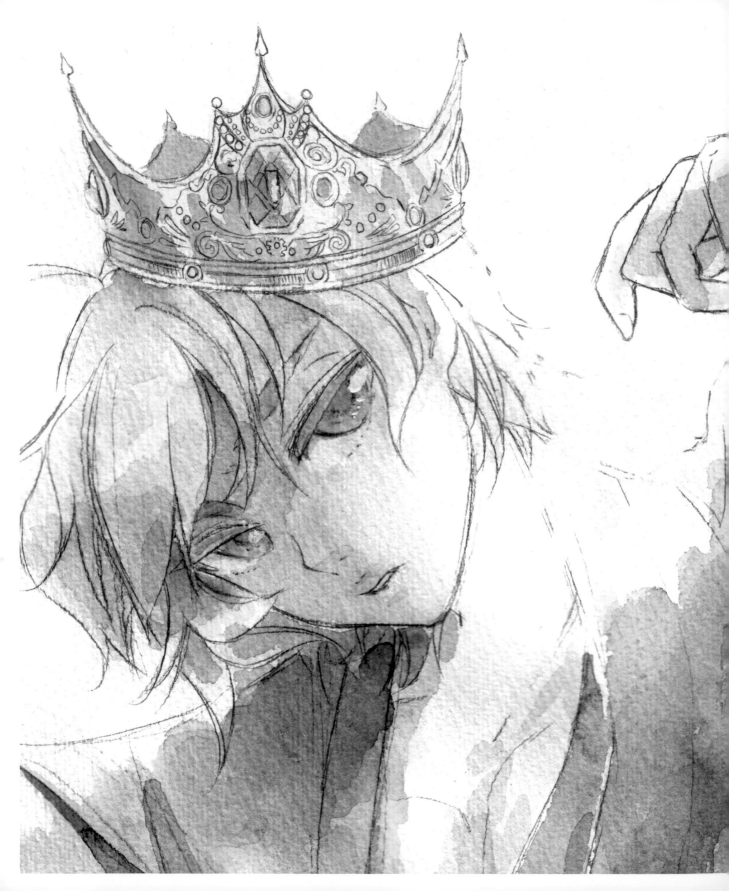

PROJECTS

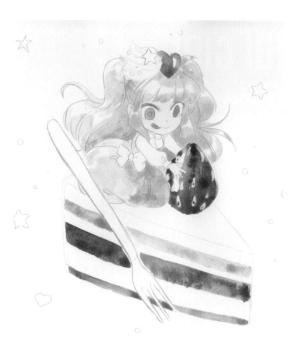

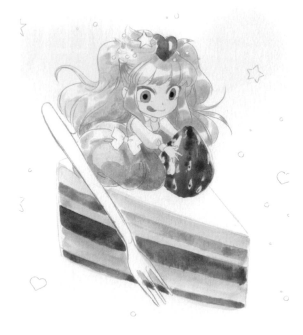

4 Take care with the dress as well, to ensure that areas where the light falls remain white.

5 To prevent the image from looking muddy, don't use a pure gray for the shading of the cake and the frosting – instead use a gray-purple. For the dress, use some lightened black, which looks like gray, and wash it over the places that fall in the shade. Only use a small amount of water and dab the brush on a cloth before you paint so that so that it doesn't run or disturb the paint underneath. You want clear shading in this picture.

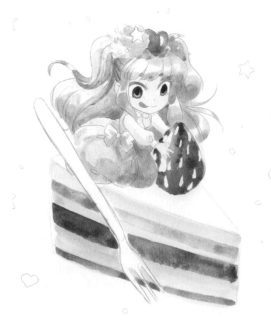

6 As the hair was still looking a little too flat at this stage, I took a warmer purple and added it to the hair color. Cool and warm can complement each other if you use them correctly. They set each other off and, as this image is to be very colorful, combining them fits well here. The eyes are also further defined in this step. Next I removed the masking fluid from the strawberry.

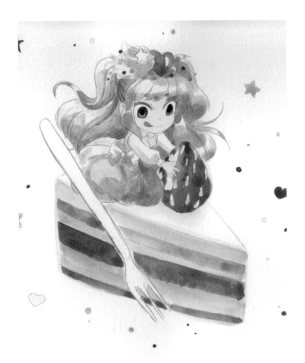

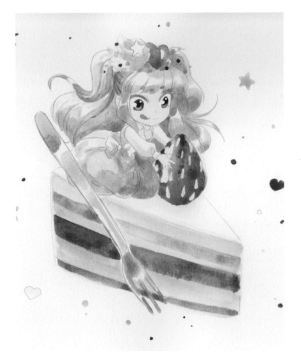

7 Here's a moment to have some fun! As the main image wasn't quite colorful enough for me, I used the background to paint small, brightly-colored motifs. They literally pop out of the picture but, as the image in the middle is so punchy, they don't detract from it – rather they emphasize it instead. Play around with this!

8 Next I turned to the fork... As it has a particularly shiny surface, I couldn't just use watercolor ground and then put shading on it. A fork is made of metal and it has many reflections, so I had to imagine that. Where would light fall on the fork? Which places could I leave white to enhance the shape of the object? By using the dry technique, I positioned these reflections simply. Finally, I put the light reflections in the chibi girl's eyes. And the image is done!

Tip:

The dry technique is a very controlled way of painting. There are only a few rules to follow (e.g. the distancing of objects or landscapes), otherwise you are completely free to try it out and have fun!

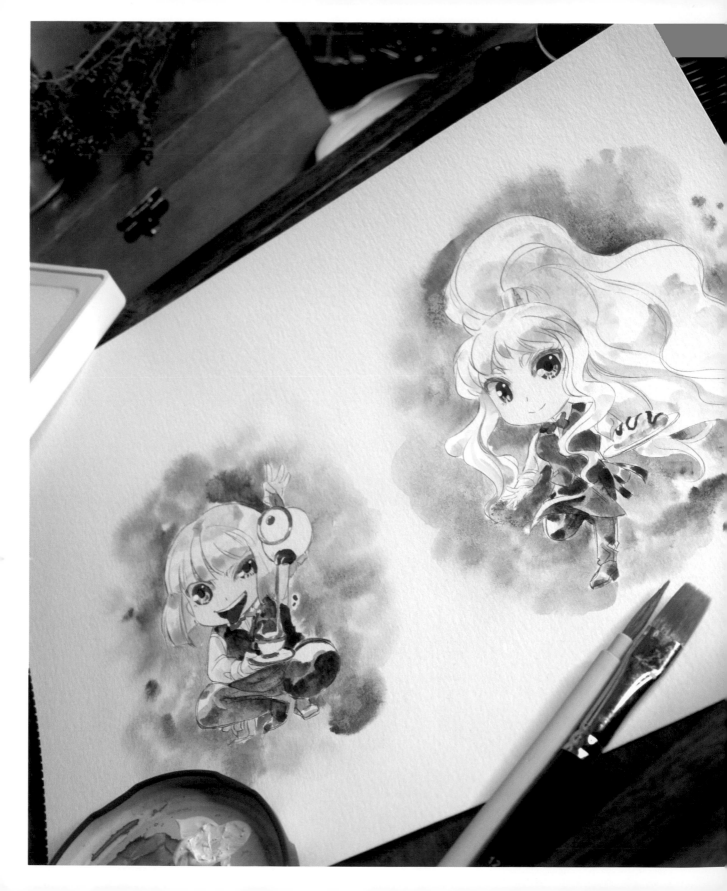

FRESH STEAMPUNK CHIBIS
against a bright background

1 First, I transferred the sketch to watercolor paper. I left out the details of the food the girl is carrying, because the ketchup that is added later looks better without outlines. Of course you can decide for yourself, but if some objects in an illustration are only indicated by color, with no prior sketching, they can look a little more flowing. Not everything has to be "enclosed" with outlines.

2 As always, the skin color forms the base from which I do the groundwork. As usual, I worked from light to dark, and the face is generally the easiest place to start.

3 Since I wanted to keep the illustration fairly loose and free, I painted the hair using the wet-on-wet technique. As always, I paid attention to the light source and left the reflective areas in the hair blank so that it shined. Mostly, these were irregular areas on the bangs (fringe). Depending on the hair length, I left some areas in the main hair blank too, and one or two in between. I also gave the strands some shine. Don't overdo it, but consider how every bit of shine in the hair contributes to the 3D effect, created with light and shadow. Too much of either tends to lead to confusion.

4 I used the accent colors from the previous step (see Tip opposite) as shading colors. That way, the pair don't become too colorful.

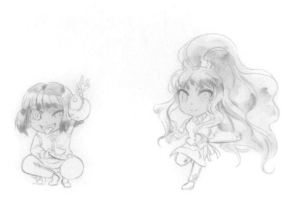

5 Next I added the watercolor ground (base color) for the eyes and tongue. The areas I have left white form the shine on the clothing. I could take a little bit of the hardness out of the white areas with a completely gray undertone, but I didn't want to this time. At certain points, such as the knee or shoulder blades, for example, I left white areas and kept the clothes more interesting than if I had simply colored them in a boring gray.

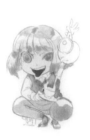

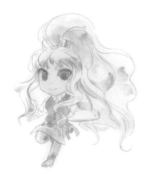

6 As I didn't like the strength of color in the eyes, I later wet them again and dabbed the color off with a tissue.

7 I gave the clothes some more shading. I always try not to overdo it, only putting shading in the places that help me to make the picture more vivid. Shading the knee of the green-haired boy, for example, can help with the perspective that shows how his leg is positioned under him.

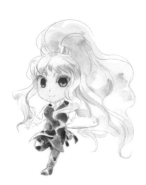

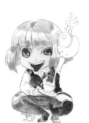

8 Next I defined the eyes.

Tip:

To make the hair look a little more interesting, I created little accents in matching colors. When doing this, I usually go on my feeling. For example, a bright red or pink would look good for the blonde girl, and for the green-haired boy you could use blue. When you've developed a feel for color, you'll find that you do it automatically.

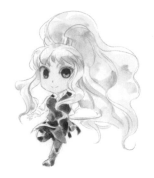

9 I shaded the shirts of the two chibis in blue. Gray or purple would also have been an option. However, as I'd already used blue in the girl's hair, blue fitted better into the overall picture and looked colorful, but not overbearing.

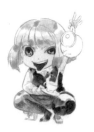
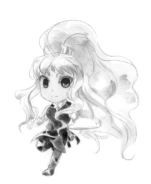

10 Then I colored the rest. I gave the boy's teapot a little decoration, colored the bows and painted the omelet on the girl's plate yellow. After drying, I immediately dotted another layer of color over it and washed the shading instead of going over it with a darker color. It's important to note that omelets don't have a uniform surface. Always be aware of the kind of surface you are trying to replicate and try to reproduce it in your own way. In this case I did this with little dots.

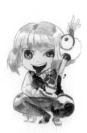
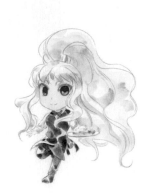

11 The final touches are a darker dot in each pupil and the reflection in the eyes.

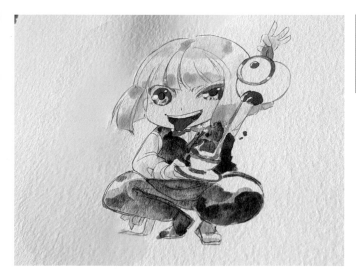

12 Since I didn't just want to paint them freestanding in the room, I wet the paper around them and used the wet-on-wet technique to create a fast but effective background.

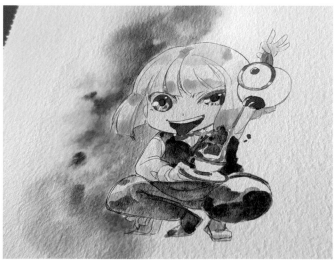

13 That way, they no longer seemed so lost, and it pepped up the whole picture.

14 Finally, I completed the omelet by painting the red ketchup on it in a wiggly line.

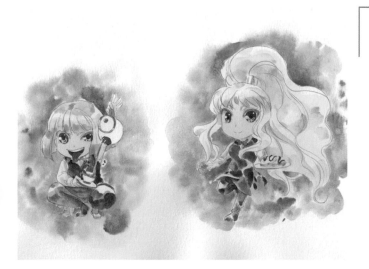

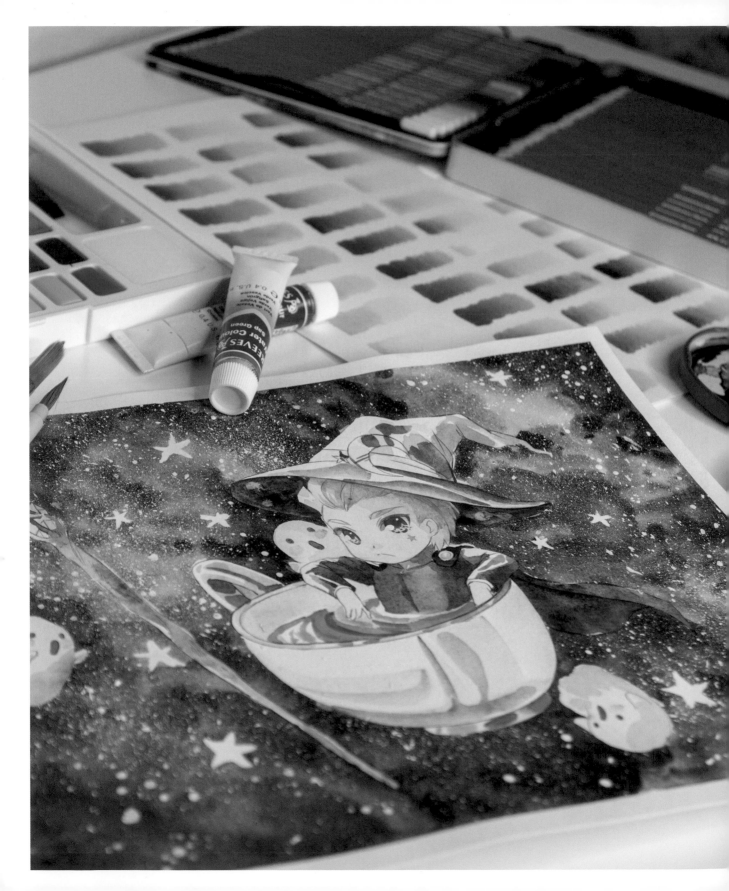

CHIBI SORCERER'S APPRENTICE
in a flying teacup

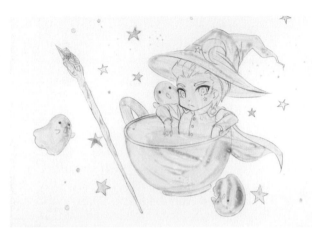

1 Start by applying the masking fluid. I always have two brushes available: a narrow one for details and a slightly wider one for large areas. Masking fluid dries very quickly, so clean the brushes immediately after use. Masking fluid dries very quickly. Mask any object that shouldn't be painted over, as well as a few extra areas to leave a bit of natural white space for the stars. The variety will make the picture look more interesting!

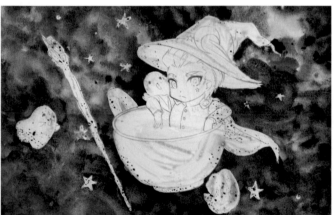

2 I used the wet-on-wet technique for the background, because I wanted the lighter colors to merge with the black. However, I didn't wet the whole picture, but only certain areas. Apply the light color here; it will become soft due to the wetness and run at the edges. Use these edges later for a nice overlapping run with the black. After you have applied the light areas, dab black paint on the picture so that it slowly connects with the light color. Wet and dry areas provide variety in the background.

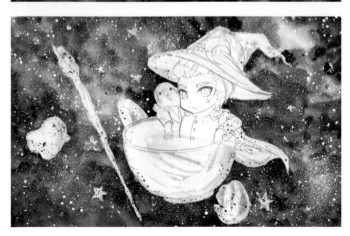

3 When the paint had dried, I grabbed a toothbrush and used it to simply flick a spray of stars on the picture with opaque white or gouache. Leave the masking fluid in place at this stage, otherwise you'll have white splatters there that you cannot cover later with watercolor paint. These may be so ugly that they annoy you, making your image beyond saving. Opaque white is stubborn!

4 When you have largely covered the picture with stars, take a fine brush and opaque white, and add a few more stars here and there. The previous spattering means that the existing stars aren't round, but you can add some more precisely now, bringing further variety into your background.

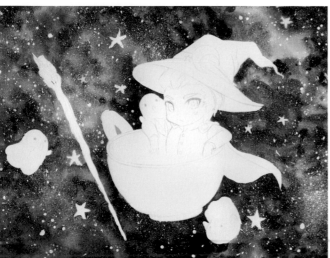

5 Carefully rub the masking fluid off the image with a tissue wrapped around your index finger. As you can see, the outlines now look a little fainter. Take another look later to see how strong you want to make them.

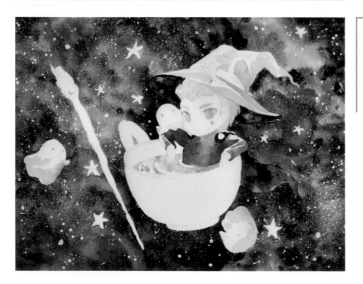

6 I added a watercolor ground (base color) for my sorcerer and for the tea, as well as the little spirits and a few stars around him. I used the wetness of his hat to create a small gradient effect and darken the inner part of the brim.

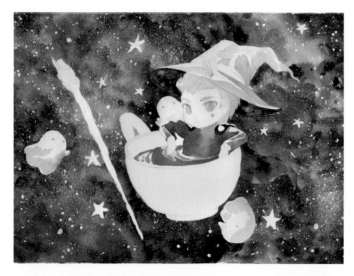

7 I gave the tea in the cup a second layer with a deeper color to create some depth to the image. The darker some areas are, the more realistic they seem, but don't paint completely over the first layer because it serves as a ground.

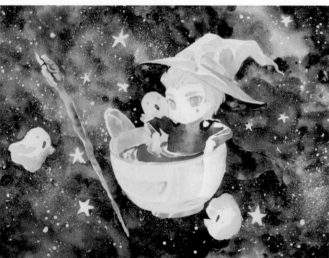

8 Then I used watercolor ground for the rest of the objects in the picture. For the cup, I was mindful of the light source, which I wanted to have on the left side, and so I left the left portion pretty much free.

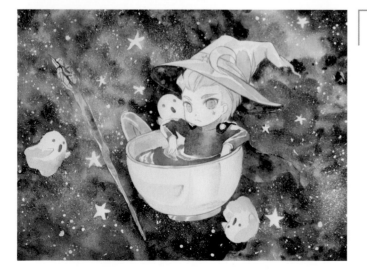

9 As you can see, I didn't like the faint outlines anymore, so I went over them.

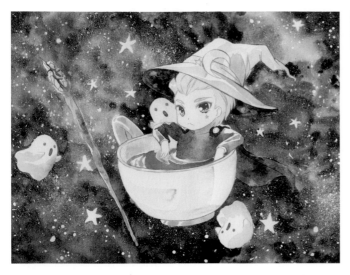

10

In addition, I defined the eyes and added opaque white as a reflection.

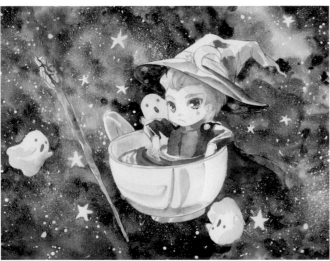

11

Next I put in the shading. I gave the cup a darker reflection, and my chibi got some light shading on the arms and face. As the light comes from the top left, the hat casts a big shadow.

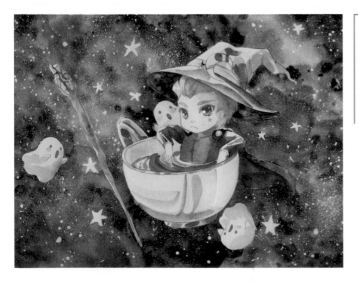

12

I added accents to define the handle and base of the cup, as well as the brooches on the hat. A gold color can be created using various strong yellows and browns. Shading for gold or silver is never quite flat, so add sketchy shading in appropriate places.

CHIBI HARRY
aka a world-famous wizard

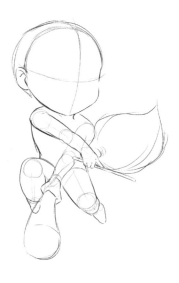

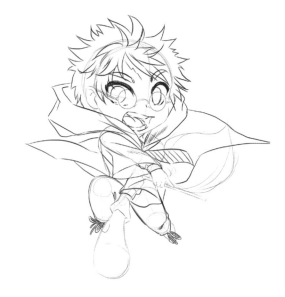

1 If you want to draw a well-known figure, you must always start with the basic frame. Draw the pose and, using a few guidelines, try to bring some dynamism to your image. Here you can see through the perspective of the broom that an impression of movement needs to be brought into the picture. This is the basis of the pose.

2 Draw the clothes and special features. We're drawing a famous wizard, so think: What are the typical features? How do you always recognize him?

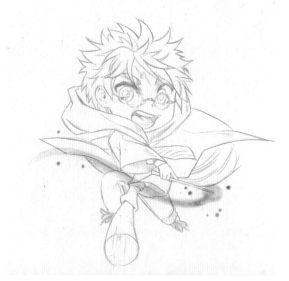

3 After transferring the sketch to watercolor paper, I covered the magic trail of the wand with masking fluid. You can leave it white later or color it using shimmering paint.

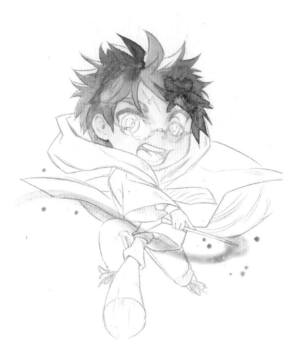

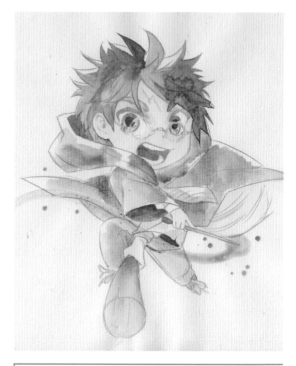

4 As always, I started with one of the lightest colors in the picture: the color of the skin. One layer was sufficient for the base color. Next came the first part of the hair. I mixed some yellow into the base color to add interest in a couple of spots.

5 Then I gave the rest of the image its base color. I left out the background, being only concerned with the character itself at this stage. Next I defined the eyes. I very rarely mix black with the base color; I mostly use a related color, as I did here. I then defined the pupil with various dilutions of the darkest eye color.

Tip:

The glasses, magic wand, cloak and of course the scar are all essential! The disheveled hair and the previously drawn broom can also help to make your wizard recognizable. Chibis are a caricatured form of normal manga characters, and it's often difficult to hit the mark with them. If you were to draw Marilyn Monroe, then red lipstick, the wavy-styled bob and her white dress would be the iconic features that identify her. You can also apply this to people around you. If you want to draw your best friend, for example, what is typical of them? What does he/she always have with them? Does he/she have a hobby in which you can put the chibi as a scene? All of this helps you to draw your chibi so that it's recognizable as the particular person you want to depict.

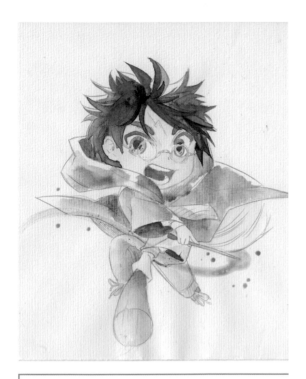

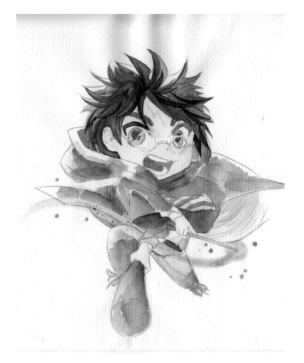

6 I defined individual strands of hair in black, using just a little water. After waiting until the first layer of strands had dried, I went over it again.

7 Then I added color to the rest of the chibi. Our wizard is known for his black hair, but his cloak is actually the same color. To prevent your picture from looking too boring, just play around with similar colors. For example, a dark brown or a blue-gray will fit perfectly. Fabric also behaves differently depending on the light; when you look at your own clothes, black is often not completely black. Remember color theory. Each shade can veer off in different directions: more towards red, or blue, or green, and so on. Play with this effect to make your picture more interesting. Watercolor is popular because of this playful, experimental quality!

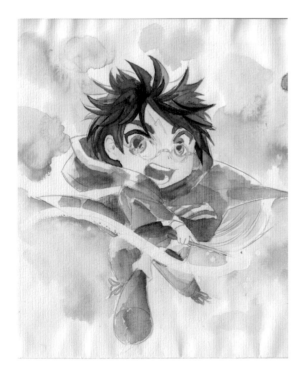

8 As I wanted to allow our wizard to fly, what could be more fitting than a blue sky? Using the wet-on-wet technique, I dabbed blue onto the background. I carefully rubbed off the masking fluid using a tissue and – hey presto – our wizard was complete!

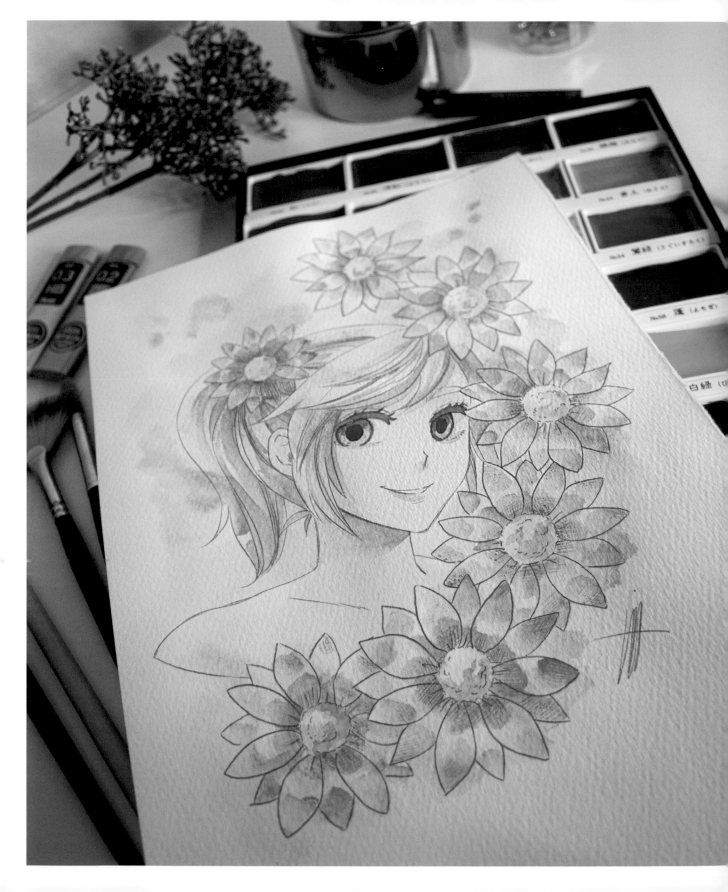

YOUNG GIRL

framed by a romantic floral design

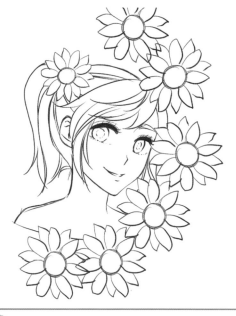

1 When creating the sketch of the girl, draw every line (shown in red), even if it will be obscured by a flower. If you guess where lines will re-emerge they will often look out of place, and you'll find that you've only drawn what you thought you saw in your head, instead of the accurate picture. If you are well practiced, you can skip this step. But I still do it. We all have to find the technique with which we are most comfortable.

2 The finished design with erased lines. Next I transferred the sketch to watercolor paper.

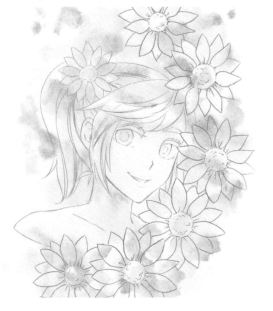

3 When starting the painting, I used the wet-on-wet technique. The background shouldn't stand out too strongly, and should be just a gentle aid. I accentuated the hair a little more, as well as the flowers. In this step, however, I tried not to create any definite shadows, but just tried things out. I already had the light conditions in my head and left some white space, for example in the hair, for the shine later.

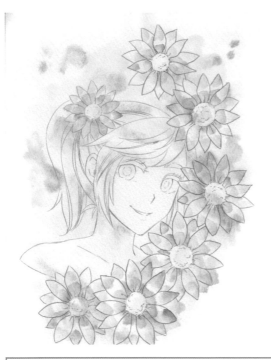

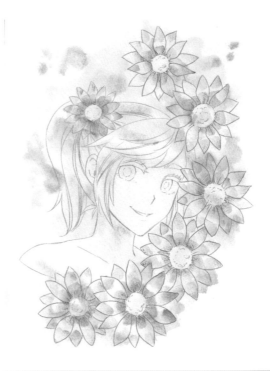

4 For the initial, soft shading, I used a slightly darker blue. If you don't have a great selection of blues, just make two or three shades using a few dabs of the main color and adding varying amounts of water. The more water you use, the lighter your color will be; the less water, the more intense. You can definitely use this to your advantage.

5 I tentatively made my flowers 3D with some initial, loose hatching (adding shading with close parallel lines). Here, I used watercolor pencils like normal crayons.

Tip:

When working on the flowers, I dabbed on some shading using the dry technique instead of covering the petals completely with color. The resulting white area (which is pale-blue in parts due to the base color that was applied in Step 1), gives the flowers a completely different and interesting note. Had I wanted to add the shading in a different base color, I would have dabbed into the initial shading from the opposite end of the petal without allowing the colors to touch.

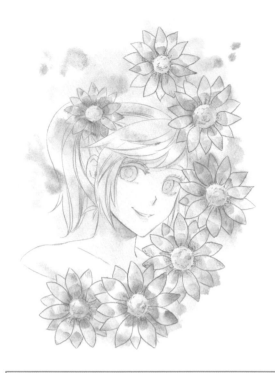

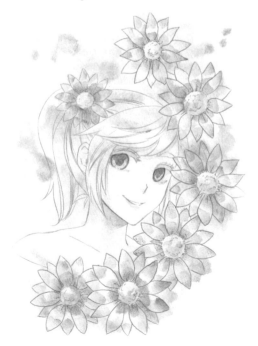

6 Watercolor pencils can either be used like a normal colored pencil or like watercolor paint. It's easier to pick up the paint directly from the tip of the pencil with the brush, instead of hatching or painting first and then going over it with water. Of course, you can do this too, but it requires a lot of practice to avoid unwanted, strong marks from the hatching. Semi-circles and curves can provide texture.

7 Now is a good time to use the dotting technique. If the paint becomes paler when applied, use it for shading on the face – as a diluted shade it's perfect here, otherwise it would be too strong.

8 Next I defined the eyes. With a sharp watercolor pencil, I could draw really fine lines, allowing me to define the pupil a little differently to usual. I could have further defined the hair at this point, but the focus in this picture is on the flowers. Creating more texture in the hair would distract too much from the background, and the flowers might not be noticed by the viewer as the main focus of the picture.

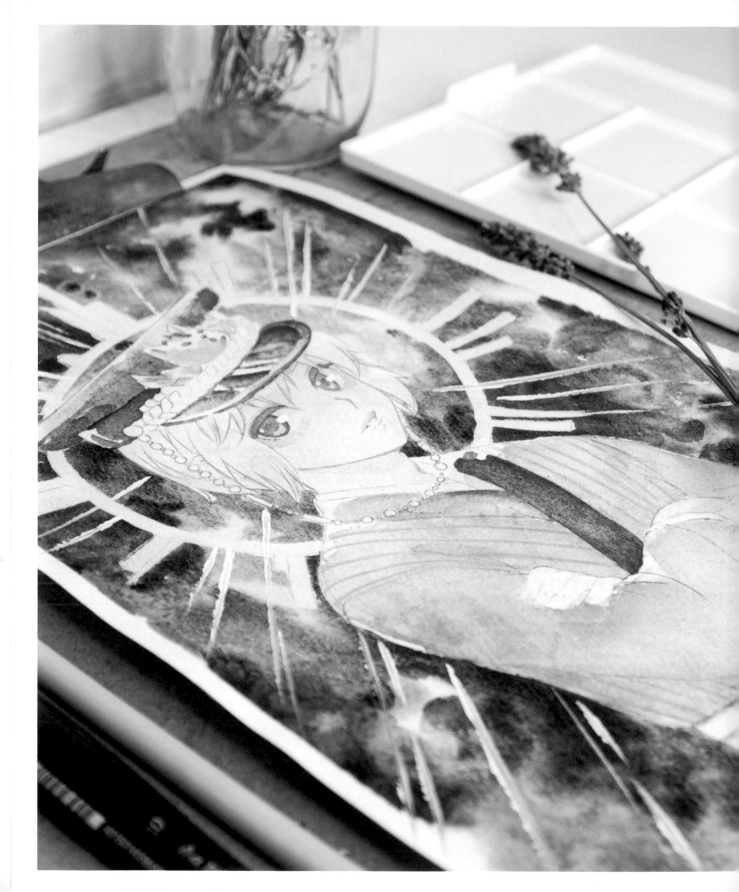

SAILOR BOY
in a symbolic sun circle

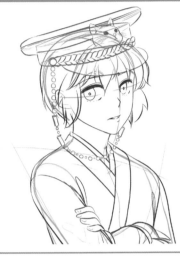

1 Use guidelines! Many people make the mistake of not completing all the lines of a sketch, and that's an error. You can't stop drawing the bangs just because they're going to disappear under the cap. They don't do that to you in real life when you put a cap on. All you have to do is finely and lightly continue the lines, even if it's only for the back of the head, as in the sketch. The point is to have the whole body sketched out so that you're able to work on it consistently.

2 The red lincs are my base, which I use as a guide. You can get red and blue leads for mechanical pencils that I always find help me to sketch freely without worrying. They can easily be removed by erasing them, or they simply fade as your hand rubs over them continually as you draw, so that they're not noticeable in the end. There's nothing worse for your picture than an artist with cramped style. These colored pencils are my tools for tackling everything in a flowing manner.

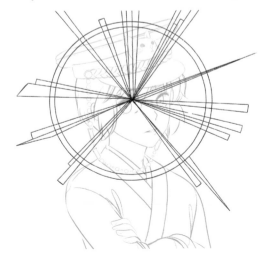

3 With a digital sketch, I can simply make the red guideline layer invisible; when working by hand, as mentioned above, you can just leave the lines as they are. They'll disappear during the painting process. For this image I constructed two circles around the head and mentally took the left eyelid as the center. Based on this, I drew my lines and defined the shapes of the rays and decorations on the sun circle.

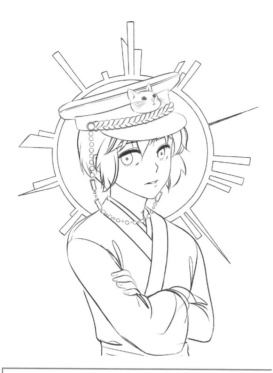

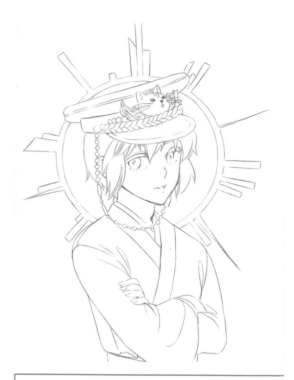

The guidelines can be erased either by hand or digitally. As I wanted the rays of the sun and the sun itself to look like a single piece, I also removed the lines in the outer circle where they crossed the rays. To put my character in front of the wheel, I erased the appropriate sketch lines, which allowed the character to stand out in front. Next I was able to transfer the sketch to watercolor paper.

This is what the finished sketch looked like on my paper. I painted on 250 g/m² coarse paper.

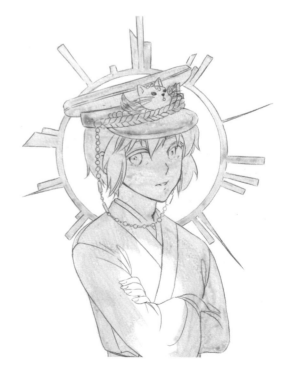

As previously described, I covered the areas I wanted to leave blank with masking fluid.

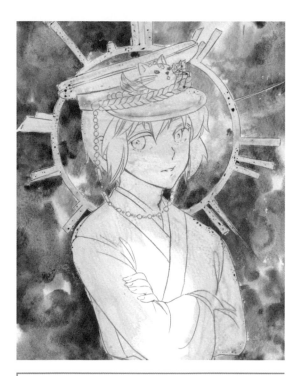

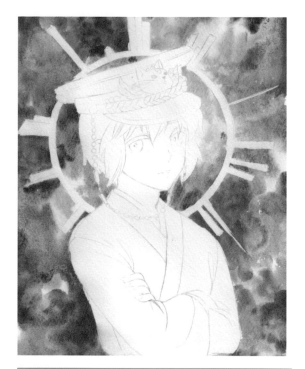

7 I wet the paper and started with black paint, to which I added some yellow in a few spots, to avoid making the background too dark. A few accents of color sometimes work wonders! Like this, the mood still wasn't exactly cheerful, but it wasn't too sombre due to the yellow. Of course, the water not only made beautiful gradients, but also deprived the black of its intensity. This also lightened up the mood of the picture a little.

8 As the background was ready for the time being, I removed the masking. As expected, it had removed some of the strong sketch lines. As I already knew that this was going to happen, I had pressed a little harder when sketching. Ultimately, you can still make out everything without losing too much detail.

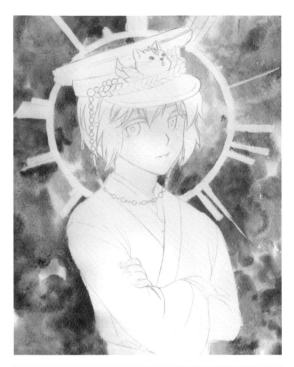

9 As I didn't want the picture to look too rigid, I applied the skin color freely, painting over the hair. The soft tone provided a base later for the hair, which I could choose to use either as a warm undertone or as a replacement for white areas. I used watercolor base colors for the eyes, hair, part of the cap, and the yukata (summer kimono). When doing this, I made sure that the adjacent areas (e.g. the yukata and belt) had dried before I applied the next color. Otherwise, they could run into each other, which I didn't want at this point. Should it happen to you, just grab a tissue and dab the spot. Wait until both sides are no longer wet, and start over by painting first one area, and then, after drying, the other. The skin color, together with the gray, created a very warm hair tone, which was the effect I was after. When choosing the colors, I also made sure that the overall effect wasn't too colorful. The base colors also appear to some degree in the background. As the blue is a cool one, I made the black of the cap a little more colorful with blue, and you can find the other colors similarly in the background.

10 When the first layer of paint was dry, I moved on to ground the rest. The red of the yukata creates a color accent that stands out. I used a cool red that would fit harmoniously into the overall picture. I gave the hair a second layer of color, bearing in mind that the light source is at the top right. Using the gray-blue hair color, I also put shading directly onto the skin. By doing this I stayed in the cool color spectrum and didn't end up with gray, muddy shading. I made the eyes more defined, and completed the remaining shading on the cap, yukata and belt. I washed the red a few shades darker with a little blue, so that it gained a purple tone in some places. At the top left of the collar, you'll see a bit of yellow from the base color. The blue made this area a little darker where I had previously shaded. It's now only slightly noticeable, but is sufficient to make the yukata more 3D. Shading doesn't always have to be that much darker or have sharp edges – you can use watercolor lightly.

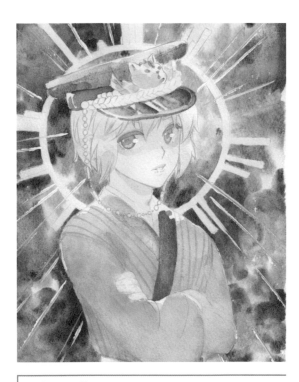

11 Since I found I didn't really like the yellow, I washed over it with blue. It took two or three layers for my blue to be clearly visible. This wasn't a mistake, because much of watercolor is also about playing around with colors. The yellow simply became an undertone, which would give my blue a more interesting tone. Make sure your brush isn't too wet when washing, otherwise you'll loosen the paint underneath and mix it up. At the end of the day, I didn't want a grass green, but a nice turquoise. In the final step, white accents were created in the eye, and the background was pepped up again. I didn't really like the effect of the sun circle on its own. I wanted more white. Of course, I couldn't bring that out anymore, because the paint had dried. Watercolor paint can be reactivated over and again, but I wouldn't have been able to create

sharp lines, and I was unsure whether I would like the mix of sharp and blurred lines. So I used white gouache to get the effect I wanted. I added the lines with a medium-thick brush, always starting in my mind's eye with the left eyelid of the sailor boy, so that the direction of the lines was maintained. As you can see, you can combine a wide variety of techniques! If you want to emphasize white areas by leaving blank paper and using the wet-on-wet technique, you must always keep in mind where your light source is. It's better to start by leaving out too much rather than too little. You can always reactivate watercolor paint, but it will never be as white as the paper was before painting.

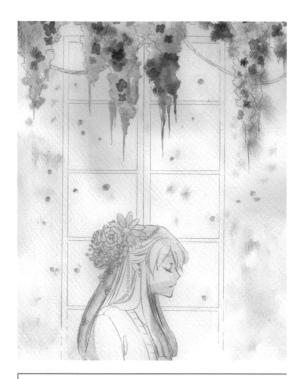

4 Next I added a cool light blue to the wet surface. The wall should have blue shading, but, to keep the picture light, rather than spreading it out over a large area, I just hinted at it a little. I also gave the flowers little accents of color in yellow, so that they didn't look too boring. Don't get too hung up about the shading, instead leave the gradients as they are. In some places they are naturally a little darker, which is sufficient for shading here. Sometimes less is more! Paint the yellow glow around the character on dampened paper, as it should only be hinted at and appear light.

5 Now rub off the masking fluid with a cloth or a piece of tissue around your finger.

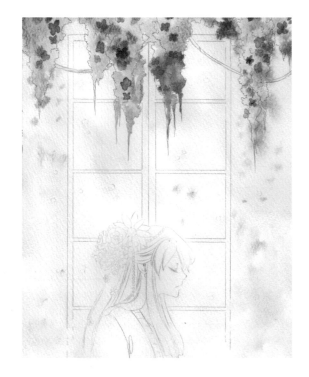

6 After rubbing off the masking fluid, you can see that the sketch lines are not as strong anymore. Leave them as they are for now and see if this works or whether the figure is in danger of disappearing into the rest of the picture. Whatever the case, you can always draw them in again afterwards.

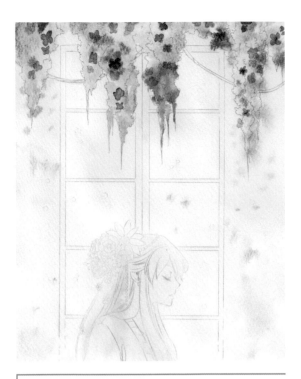

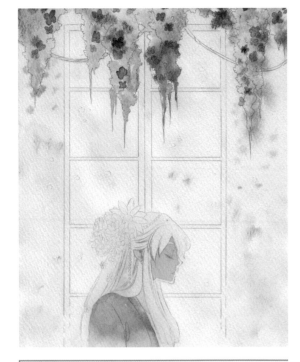

7 Wet the character and distribute the same cool blue of the wall as a base. The light source is shining through the window, so the figure is shrouded in shadow apart from a few edges.

8 I wanted the shadow to be gentle and not as intense as it would be in reality, so I kept the shadow color light. Then I painted the skin color. The face was very intense, but this could look quite effective in backlight. I left it that way for the time being. By reactivating the color with water, I could always remove some of it or soften the effect a bit later. As always, it's a question of trying things out until you get the result you like. I then painted the girl's jacket wet on wet.

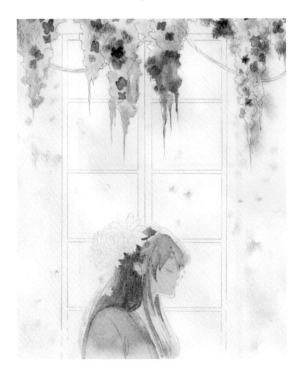

9 Next I painted her hair, paying attention to some blank areas at the back of her head and on the strands in front of her ears. Not everything needs to be in the base color, you can also use the light blue shade for the light areas of your subject. This gives the whole figure even more of a 3D feel, and for a backlit object this effect is perfect!

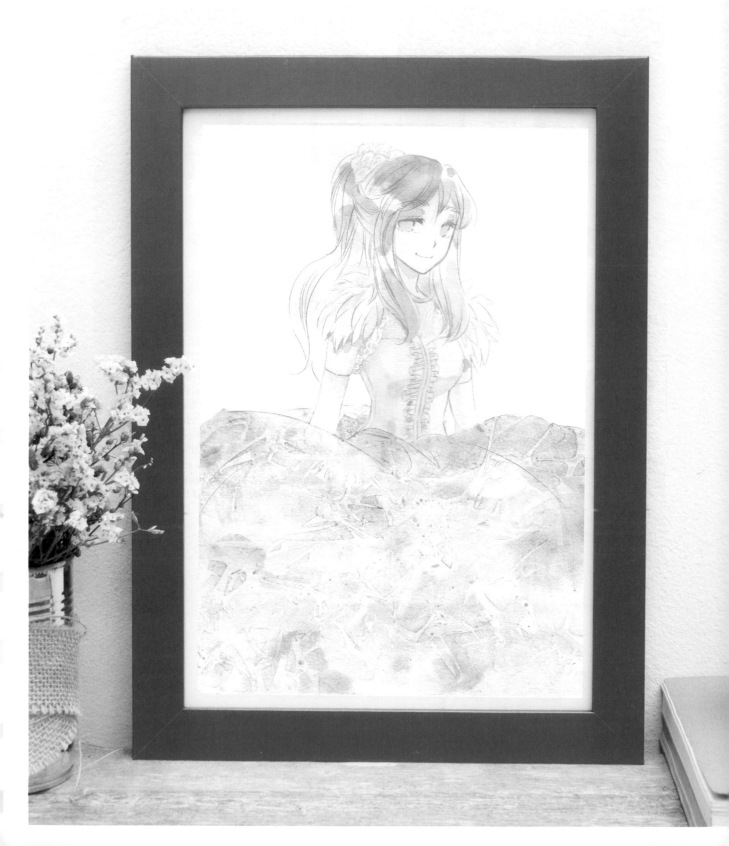

HISTORICAL HEROINE
in a voluminous ballgown

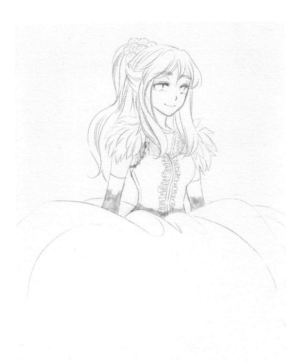

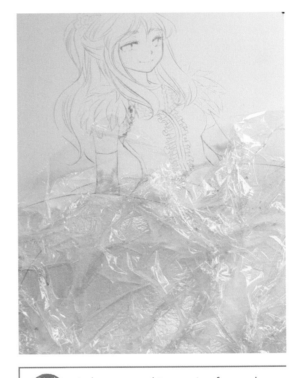

1 To protect the image in a few key areas, I used masking fluid to preserve a crisp edge between the skirt and the rest of the ballgown.

2 I chose a cool turquoise for my base color. Film can sometimes produce idiosyncratic results and I didn't want to take any risks. I always make sure that the paint isn't too flooded before applying the film, otherwise you have to wait a long time before it's dry enough to remove the film. After a while you develop a feeling for the waiting time: sometimes it's a few hours, sometimes you have to leave it overnight.

3 After a night, you can be sure that the paint has completely dried, and even apply a second color.

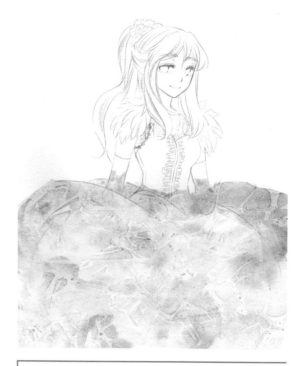

4 As I didn't want to reactivate the underlying color, I needed to be careful with the amount of water I used. I put the film on the picture a second time, pulled it around a bit and laid out the pattern in a way I liked.

5 This was what my finished film pattern looked like on the dress. Now I could remove the masking fluid and start with the rest of the picture.

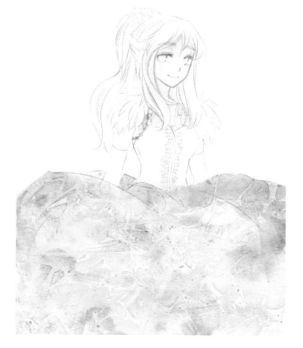

6 First, I applied the skin color.

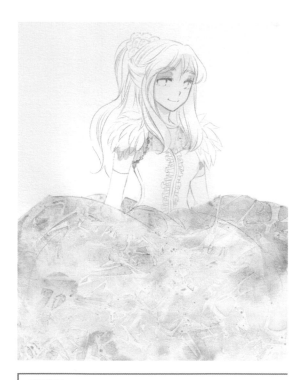

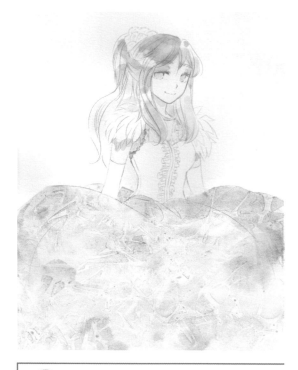

7 With the loose color and style of the pattern on the dress in mind, I created the shading very loosely too; painting over the sketch lines in places.

8 To prevent the hair and eyes from attracting the viewer's attention too much, I simply left them soft and without much shading.

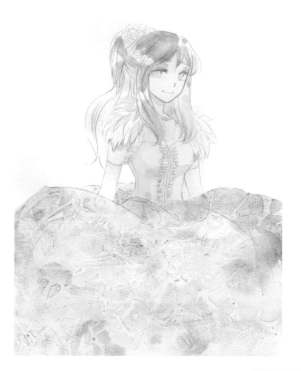

9 Finally, I colored just the pale shading on the corset, gloves and shoulder feathers. Again, I made sure that they didn't become too intense and distract from the gorgeous skirt. To ensure some variety, I added a little green into my gray for the corset, and some blue as shading for the feathers.

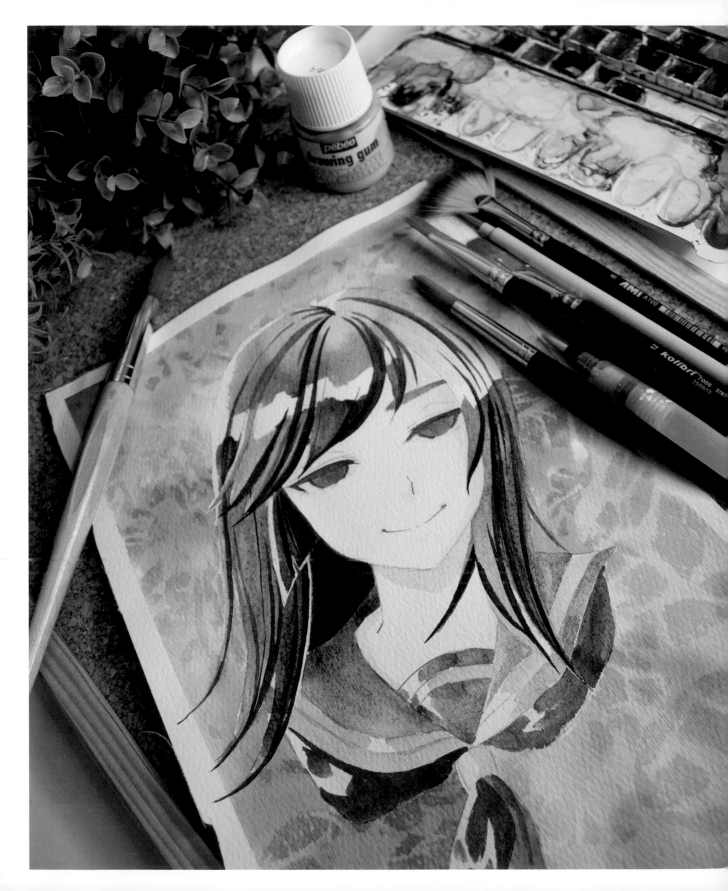

MELANCHOLIC SCHOOLGIRL
against a fluorescent background

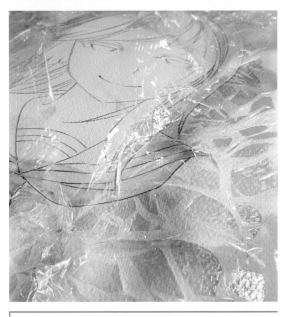

1 Using this image, I'll show you another method of paint application. Before coloring the background, I masked inside the edges of the image (in the tried-and-tested way!). Then using the wet-on-wet technique, I dotted various shades of blue onto the picture's background and put plastic film over it, just as we did in the previous project.

2 You can pull the film about a bit as long as the paint is still wet. You'll be able to see where you'll have light spots in the pattern once it's dry.

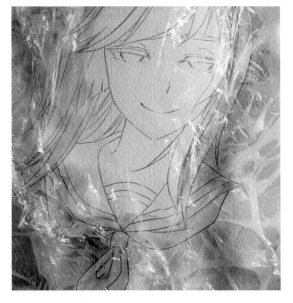

3 Sometimes there are ugly little lumps of paint, which you can break up and disperse a bit. Whatever you do, wait overnight to be on the safe side before moving the film. If you take a look in the meantime and haven't noticed that the color is still wet, you'll find you break up your pattern, so it's better to leave the film on longer rather than not long enough.

 Once it's dry, you can carefully peel the film off. Now, we can turn to the rest of the image to see how the background works with a certain color scheme.

 I rubbed off the masking fluid and applied the base color for the face with plenty of water. Once again, I deliberately painted over the edges and into the hair a bit.

 Immediately after that, I applied the shading. As the background is a cool blue, I also used a cool, albeit lighter blue for the shading.

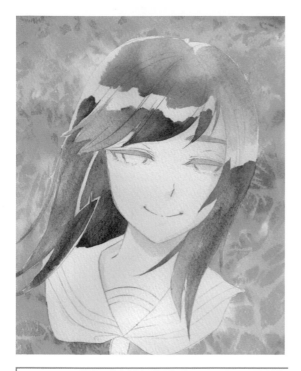

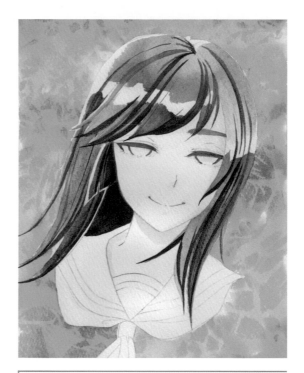

 7 I colored the hair using a lot of water. I started on the left side of the head and let the color fade out to the right with the wash. By continuing with a strong color under the shine you can achieve a nice effect, which I also repeated on the bangs (fringe) and again on the left side. In this way you can make the hair area more interesting than painting a flat surface would be. I also colored the eyelids in the same color, so that the face looked softer overall. You don't always have to paint black eyelids – often you can give the face a little something extra by using the hair color there.

8 Next I gave the picture a little more depth by putting dark shading in the hair. The area on the left between the neck and the front strand is the perfect spot for this.

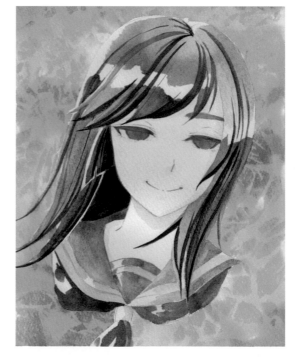

9 I left the remaining strands a little thicker and avoided using large shaded areas to keep the image soft. The rest of the picture was enhanced with one pass of color. The only highlights I used were made by leaving some areas unpainted. So the rest is colored, but because of the detailed hair, the focus is drawn to the face.

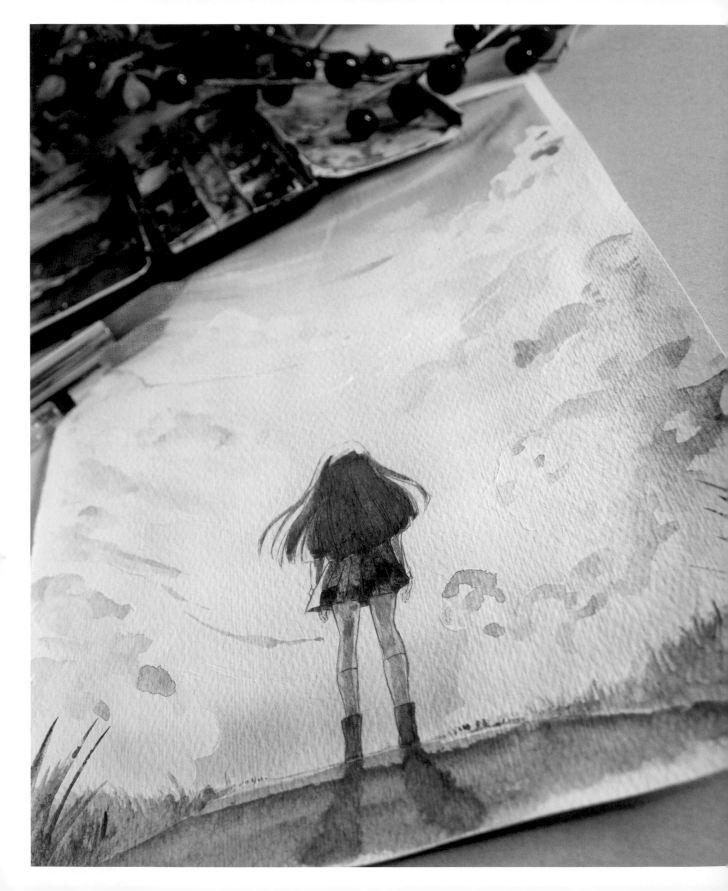

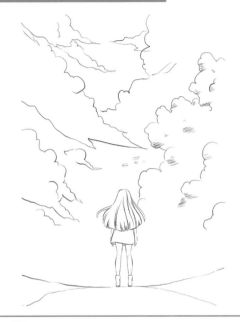

1 Before the sketch is transferred to watercolor paper, you need to determine the perspective. Of course, you can just draw the clouds normally, but if you bend them a little to form them into rings, you can breathe a little more life into the image and make it more exciting. To achieve the effect I wanted, I added a few more lines on top of the sketch of the figure and defined the clouds a little. That way, I had the rough structure in mind. It's always better to prepare the sketch as fully as possible, whether digitally or by hand.

2 This is what the preliminary sketch looked like without guidelines.

3 And this is what the sketch looked like transferred to watercolor paper. Since I would be working with backlight, I drew the outline of the girl a little more strongly. She'll get a darker color, and much could be lost if the sketch lines are too light – I might not be able to see and trace them later.

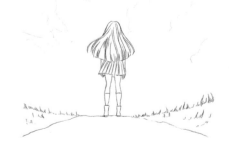

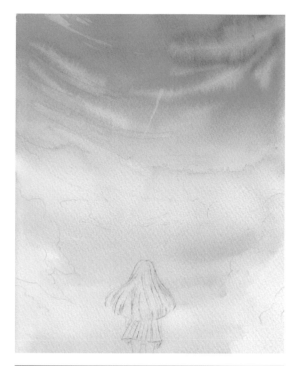

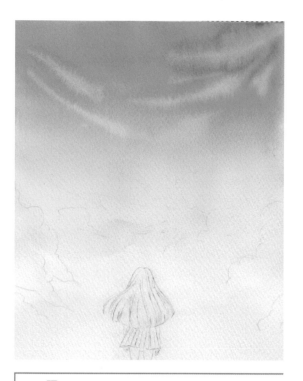

4 I wet the upper part of the paper and added a wash. After washing the blue to the degree I wanted, I used the wet brush to remove color from the clouds.

5 Through the gradient exercises, you will already have some ideas on how you could blend color in the lower area of sky. I opted for a soft pink. As you can see, in the middle of the picture there's a white stripe running up across my clouds. This is where I used the hair dryer too quickly and held it too close to my picture when drying – this light area was the result. After the gradient had dried, I worked with an initial layer of white. I used diluted white gouache, but you could also use opaque white, it's up to you. I wanted to get just a little more definition in the cloud shapes, so I only used medium-coverage paint, which I diluted a lot with water. This way, I could always add more layers if I wanted.

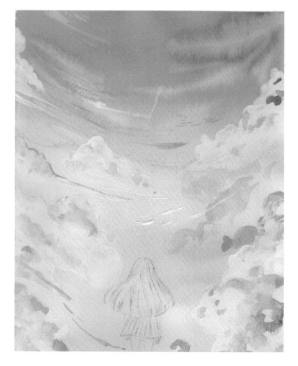

6 I shaded the clouds according to the degree of gradient of the sky, adding small, blue stripes at the top of the sky for more distance and dimension. These appear to be higher and trick the eye.

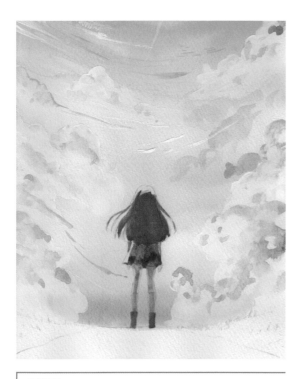

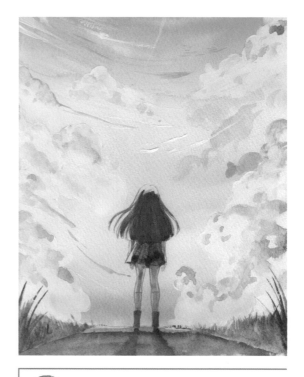

7 I applied the base colors for the girl, then put blue shading over everything except her uniform. Don't pull it right to the outlines, so it looks as if the light is nestling around her.

8 Next I added the wash for the middle ground. I decided that one layer of green wasn't dark enough for the mood in the picture. If the sun is not shining directly onto the objects, I like to wash the images one or two shades darker. This way, you can slowly adjust the color to the atmosphere of the image. I also re-drew the outlines because they seemed too soft to me. In order to make the picture a little more 3D, I drew more detailed blades of grass on the left and right. This makes the viewer feel even more included in the scene, as if they are looking up at the girl from below. To complete the mood, I washed another layer over the brown ground.

9 For bodies and objects standing on the ground, always make sure that the shadow begins where the object touches the ground. The picture is finished, and the white stripe across my clouds, that I might have considered a "mistake", has blossomed to become the center of attention!

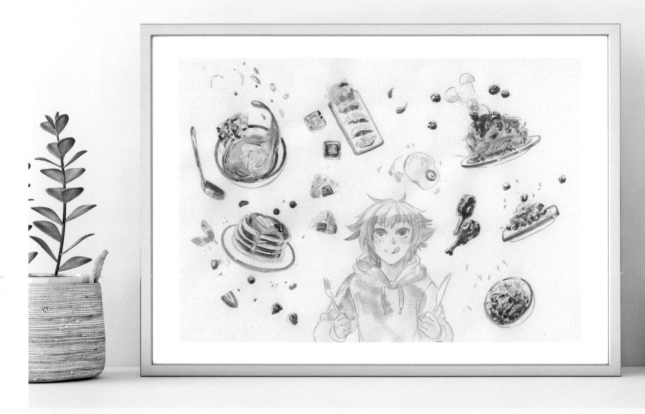

FOOD OVERLOAD
boy in the land of plenty

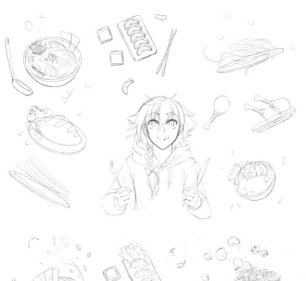

1 I made my initial sketch just a rough one, as usual, otherwise you can get lost in details that will no longer be visible when you trace the image onto watercolor paper. Approximate shapes and the perspective of the plates and bowls are important, though, and these can be very time-consuming to get right, so I'm always careful with the sketch.

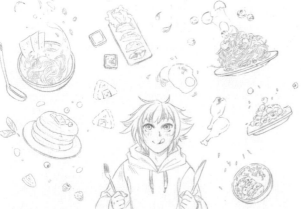

2 The finished sketch contains more detail. Theoretically I could leave out a lot of these lines, but with this picture I really wanted everything to be a little more detailed and to be able to see it "detached" in pencil. Depending on which dishes you draw, there may be a confusion of colors and white areas later. If that's the effect you want, that's perfectly fine, but the effect could jar with the other images, and the overall picture will no longer seem harmonious.

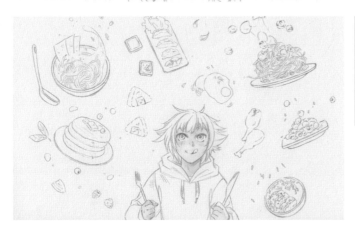

3 First I roughly applied the skin color. In contrast to the dishes, the boy is more loosely colored, which is why I didn't go into too much detail. Of course, you're free to decide for yourself what level of detail to include, but for me, the boy's central position was enough to make him the focus of attention in the picture.

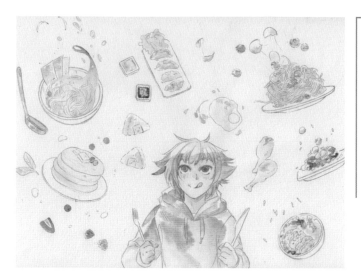

4 Next I gave the hair, eyes, tongue and hoodie an initial a layer of paint. To prevent things from looking too flat, I left white areas to indicate the shine and folds in the clothing. As a small highlight, I added some yellow to the shine in his hair. Then I applied the base colors for the food. Pay attention here to how the light falls, e.g. with the noodle soup. In doing so, you can leave some white spots blank for the shine. With opaque white you can make a lot of things shine, but it will never look as light as a natural white area of unpainted paper.

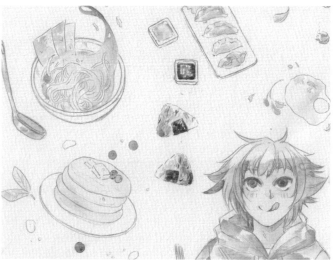

5 I then turned my attention to the onigiri and its spotted green seaweed. As these items are small, I used a dark green, but made sure I left enough white area. Seaweed has a special way of shimmering, which you may have noticed with dried seaweed or sushi. The best way to mimic this is with dots. Make sure they look a little random, and not too round. The individual flecks are quite triangular or square in appearance. I defined the seaweed with another layer, this time in black. By doing this, I added a little more realism. I then used the black to define individual grains of rice using the brush tip.

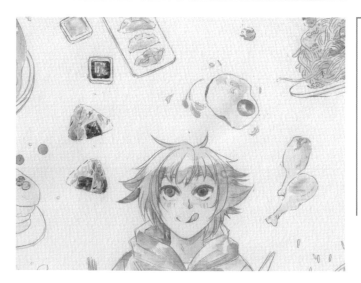

6 Next I focused on the fried egg. When using the watercolor ground (base color), I had already made sure that the slight hint of color was not just gray, but also a little yellow. If you look at a fried egg in more detail, you'll notice that there are many colors that you can use to paint the illustration in a more varied way. I started the egg yolk with a bright orange and paid attention to the fall of the light, which I left white. As the pale color of the egg white was a little too weak for me, I painted another stripe in yellow. In addition, I have also colored the edges a little with brown here and there, so that it looks well cooked.

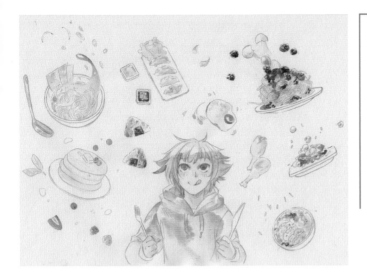

7 To add more depth, I emphasized the egg yolk with a slightly darker orange on one side. For the spaghetti plate, I first shaded the meatballs a little by dabbing on a reddish brown. I left white highlights where they might shine due to the sauce. The egg on top is colored in a similar way to the fried egg, but it's not cooked, so it's sufficient to emphasize the egg white with a little gray, following the shape, i.e. somewhat rounded. This yolk doesn't need to be embellished with any dark orange either, as this color only tends to appear once an egg is cooked. Next I added a little extra definition to the pasta.

8 I moved on to add a little sketchy coloring in reddish brown to the chicken drumsticks, which already looked quite juicy and succulent. I used an intense color directly on top of the base color. The spices and batter on the meat require strong coloring and are an invitation to dare to use intense shades. If you paint the dark spots using too much paint, just leave them like that. No batter is perfect, some is only dark in certain parts, while other batter varies from dark to light across the product. I emphasized the pasta in the spaghetti dish a little more, adding brown to parts of the mound of pasta, because next to the chicken drumsticks this dish appeared too pale.

9 In order to bring a little more depth to the chicken drumsticks, I added to the batter again with a slightly darker color. You can sometimes see the texture of the chicken skin, so I dabbed small dots here and there on them to indicate this. Using the same dark color I went directly over to the mushrooms because the remaining color on the brush was perfect for this. As the mushrooms were very shiny, I only emphasized the stalks and a few of the curves. That's how I left them. It's the same procedure as for the spaghetti plate: I could always go back later, but it was enough at this stage.

10

The surface of soup is similar to water, but with noodles and seaweed in it. You can't just mimic a smooth surface, and as I've set my soup in motion by spilling it out of its bowl, this wouldn't look right anyway. First, I shaded the noodles a little with an ocher color to see how they looked. The top of the pile of noodles is right in the center, whereas those at the bottom left lie deeper in the bowl and needed to be shaded more. Next I applied a darker orange-red, painting over the portion of the noodles that was covered in soup. Make sure that the orange-red isn't too wet, otherwise the color underneath will come off.

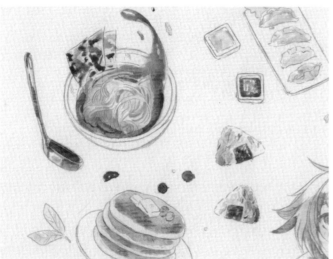

11

I worked with gouache for the pancakes, because a light yellow watercolor didn't work for the syrup. You could see traces of it on the lighter parts of the object, but it looked much too watery. I was starting to feel my way towards the shape of the pancake stack. The base color was a saturated yellow or very light ocher, then I added brown to the flat sides of the pancakes to define the thickness of each one. With the first pancake, you can see that I've left quite a large light edge, so that it looks thicker than the ones below. I now colored the remaining white areas in base colors. Next I moved back to the soup. The focus is on the seaweed and the spillage from the top of the bowl – I indicated this with small splash-like curves.

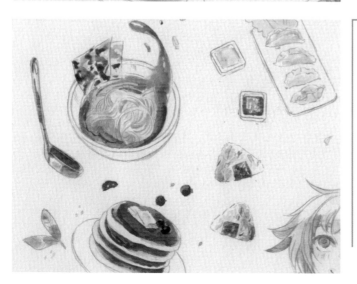

12

Then I colored the right side of the soup a little more intensely and painted soybean sprouts and spring onions above the soup bowl. A simple base color with white areas was sufficient here. I roughly dotted the seaweed again, like I did with the rice balls. Using only a little water and, therefore, an intense color, I took a little red on my brush tip and created other small accents in the broth and in the drops that result from the spillage. The pancakes weren't dark enough for me, so I put another layer of brown over them. As darker spots around the edge often appear in the pan when cooking, I added some here and there to help define the surface.

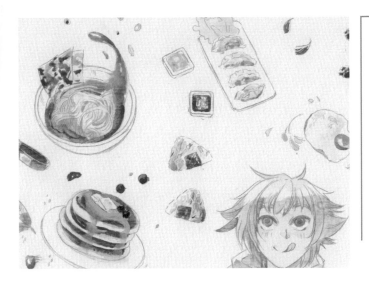

13 I further defined the fruits on and around the pancake stack for a more vivid impression. Then I applied the layer of yellow gouache for the syrup. With gouache you can use more water to dilute the color a little afterwards. Syrup is viscous, so the color should be intense, but aim to let the pancakes beneath shine through it. Next I moved on to the gyoza directly above the boy. One side is always fried, the other remains light, so I left a few white areas initially, where the shine would be. In this step, I painted the first color of the fried side and made sure that the base color always shone through. You can a little more detail to the garlic with stripes.

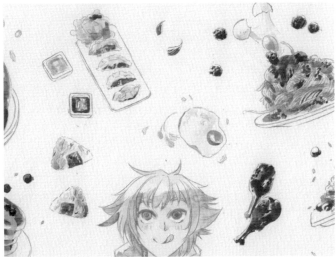

14 I roughly shaded the salad by darkening the side lying on the plate. This makes this part look flattened while the lighter side appears to stretch upwards to give a 3D appearance. I also dabbed another layer of color onto the fried side of the gyoza to get the final fried effect that I wanted.

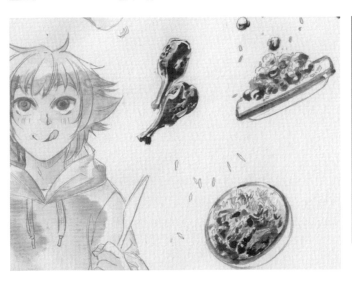

15 As with the meatballs, I dabbed along the meat in a dish in various shades of brown (always with a dash of red), paying attention again to the light source. The dabs needed to be larger than for the spaghetti meatballs, as those were smaller due to their minced meat consistency. Here I have drawn the meat cut into strips, so the dabs are a mixture of long and short, but never round. Next I highlighted these dishes again by decorating the plates in a uniform style, with a blue border. As plates are normally glazed, the edges should shine, so I didn't always completely fill the area with blue. Finally, shine and reflections were added with white gouache.

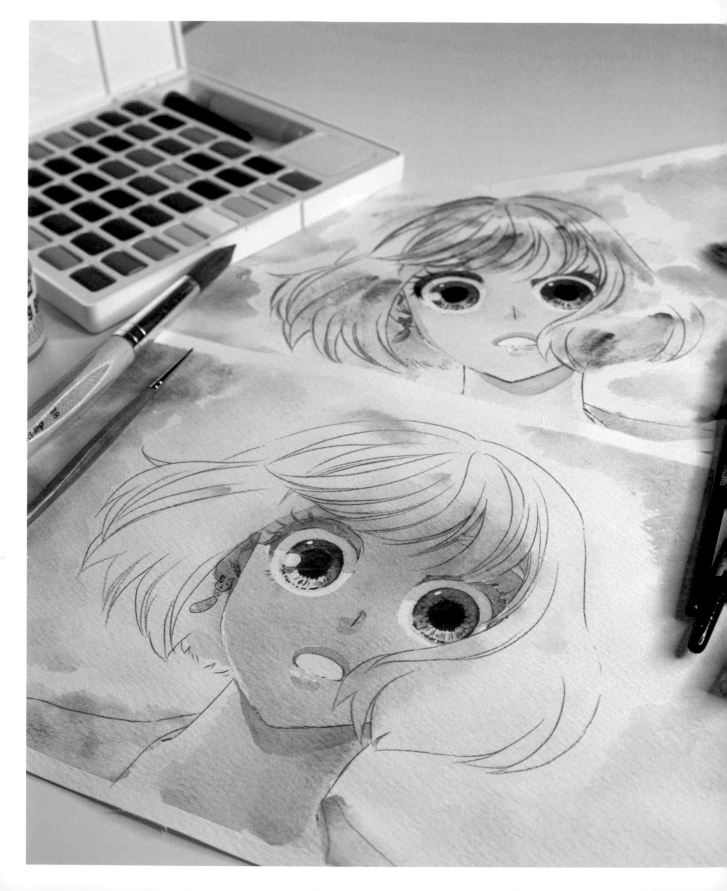

GIRL'S FACE
with expressive eyes

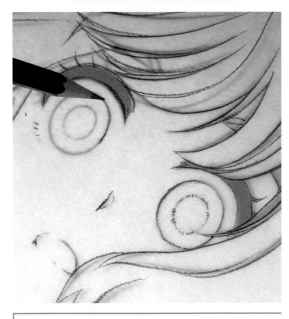

1 To save time, I didn't draw many details in the initial sketch. I only hatched in an outline of the iris when I'd transferred it to watercolor paper. The sketched circle served as a guideline. You can do this with a lot of small elements – I like to save time so that I can start painting! Even with small things, such as earrings, I often only draw them in the final sketch on the watercolor paper.

2 As the eyes will be the focal feature when the picture is completed, I masked them with masking fluid.

3 I applied a warm tone for the skin color, which I made a little redder than usual due to the backlight. I applied two layers to make it more intense. As the light source is behind the girl, I left some white on her neck to emphasize the effect. Before I colored her hair, I wet the paper both within and outside the outline. The watercolor for the skin was reactivated again by the water so the colors would merge.

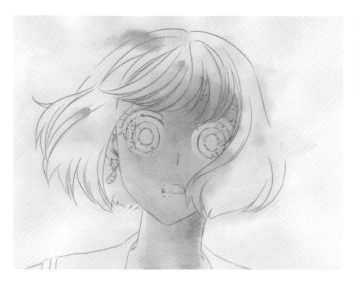

 Next I applied the hair color generously, so that overall the resulting picture would look softer and slightly diffused. Overpainting makes your image look looser than if you kept the color within the lines.

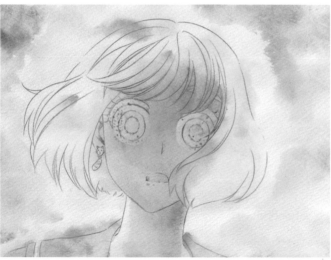

5 As you can see, I added a yellow to the green. This injects a little more variety to your coloring. Watercolor lets you experiment so that you can vary your coloring. As with the background, I also colored the collar of her uniform using the wet-on-wet technique. Here, as with the hair, I added some yellow. This, combined with the red of the background, hints at a sunset.

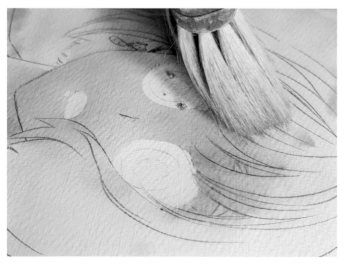

 Next it was time to rub off the masking fluid. I usually sweep away the rubbed off bits of masking fluid with a soft dusting brush. I often blur bits a little more here and there with my hand too.

7 As I no longer liked the faded outlines, I traced over them again. Sometimes I wait until just before the picture is finished, either because it doesn't bother me or because I want to see if the pale outlines may aid the overall atmosphere. I shaded around the eye to make it look more alive.

8 Of course, I could leave the whites of the eyes white. However, if I did, I would have three white areas in the picture, including the open mouth, which would all stand out equally. I wanted to mitigate this effect a little bit, so I took a very light green to soften the white somewhat. For the eyes, I wanted a warm brown tone. To make the eyes stand out more, I chose a very light brown for the base color. I painted over the outlines of the eyes again to make them appear softer still, without altering the light feeling of the image.

9 I shaded around the eyes so that they were more expressive. Then I used darker brown tones to define them further. I made sure that the darkest point of the eye was always in the middle, in the iris. You don't have to make the entire area dark; it'll be fine if it's similar to the example image. That way, it doesn't jump out at you, but is the darkest area and fits into the overall picture. If I had painted with a flat, dark brown, it would have been far too conspicuous.

10 When you step back and take a look at your picture, you can change the dynamics and the strength of the color gradient a little more and play around with it until you like it. I like to make the colors shine a bit more and look more intense.

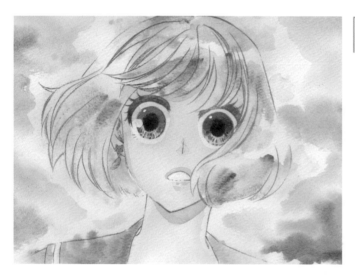

11 This is how the same image can look when you use cool colors.

Tip:
A homemade color chart with mixing ratios is not only fun to create, but also saves you a lot of time and worry, as you always know which color works.

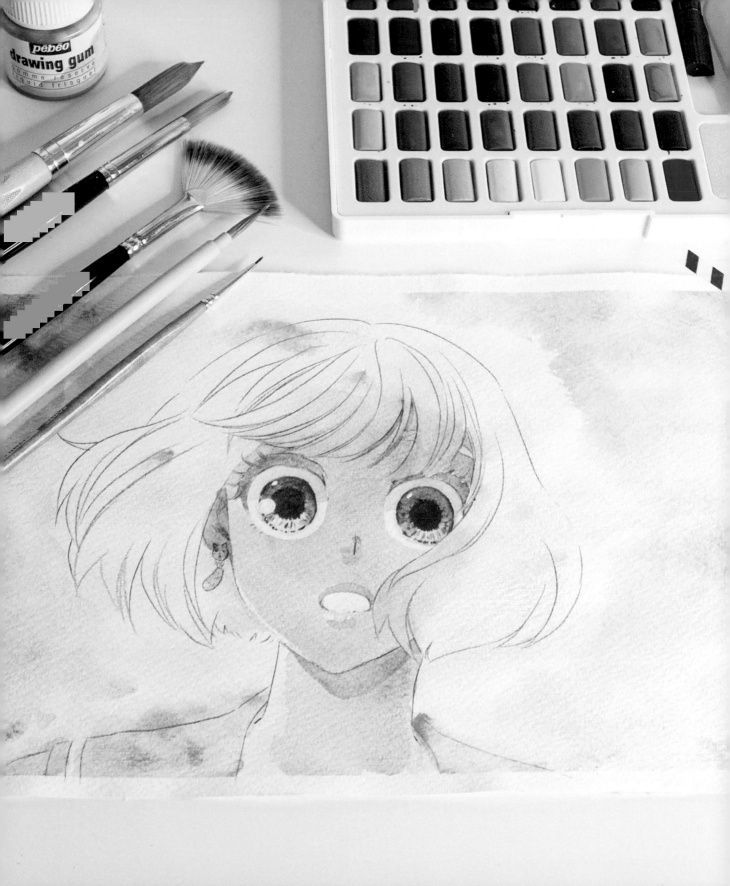

About the author

Lisa has been drawing pictures since her early childhood, developing her love for manga style early on through anime like "Heidi" and "Sailor Moon". After studying communication design, she spent a year in Japan, where she decided to devote herself full-time to illustrating and storytelling. Specializing in manga, her portfolio includes Nike, EMF, Tokyopop, Carlsen Comics and various other clients and publishers.

She also attends conventions and works on her own manga series "Mechanical Princess" (nominated for the German Phantastik Preis (Fantasy Award) and "Rabenfluch" (Raven Curse).

WEBSITE: lisa-santrau.com
INSTAGRAM: @lian_illustration
TWITTER: @LianCircus

Acknowledgements

I should like to thank Faber Castell for their kind support and the provision of some materials. In times of overcrowded advertising markets, it's hard to find words that don't feel overused and fake. I was really impressed by the watercolor box. I'm also working with it on my private projects and would genuinely recommend it.

Thank you for your trust in my editor Marcelina Schulte and in me. I hope you like the book!

At this point, a big thank you to my mother and sister too, who endured my panicky outbursts just before the deadlines during the tense phase with my laptop. Special thanks go to my little sister, who always cooked during these phases and made sure I didn't starve! Many thanks to Lara Nelles, who is responsible for the particularly beautiful design of this book. And has creatively implemented all my wishes.

And last but not least, thanks to my editor Marcelina Schulte, who is really committed and so patient with me! Here's to many more projects (and if not, we'll just have a coffee together when I'm around!).

Index

A DAVID AND CHARLES BOOK

© 2020 Edition Michael Fischer GmbH, Donnersbergstr. 7, 86859 Igling, Germany

This translation of MANGA WATERCOLOR first published in Germany by Edition Michael Fischer GmbH in 2020 is published by arrangement with Silke Bruenink Agency, Munich, Germany.

David and Charles is an imprint of David and Charles, Ltd Suite A, Tourism House, Pynes Hill, Exeter, EX2 5WT

First published in the UK and USA in 2021

Lisa Santrau has asserted her right to be identified as author of this work in accordance with the Copyright, Designs and Patents Act, 1988.

A catalogue record for this book is available from the British Library.

ISBN-13: 9781446308479 paperback

This book has been printed on paper from approved suppliers and made from pulp from sustainable sources.

Printed in Slovakia by Polygraf Print for:
David and Charles, Ltd
Suite A, Tourism House, Pynes Hill, Exeter, EX2 5WT

10 9 8 7 6 5 4 3 2 1

David and Charles publishes high-quality books on a wide range of subjects. For more information visit www.davidandcharles.com.

CREDITS
Cover design: Lara Nelles
Project management and editing: Marcelina Schulte
Layout & typesetting: Lara Nelles

Photo credits:
Painted area on front page: ©Magnia/Shutterstock; circular "Tip" boxes: ©Nik Merkulov/Shutterstock; p. 13 board: ©Aniustudio/Shutterstock; p. 14 watercolor paper: ©Katya Polnoch/Shutterstock; p. 14 eraser: ©mimibubu/Shutterstock; p. 22 arrows: ©Paint Brush/Shutterstock; p. 34/35 sun: ©mimibubu/Shutterstock; p. 80: Julia Sudnitskaya/Shutterstock; p. 112: ©Rakic/Shutterstock; p. 118: ©ptystockphoto/Marina_D © Shutterstock

We should like to thank Faber-Castell for providing the materials used in this book.